honorary member of the United Society of Artists and is listed in the current edition of *Who's Who in Art*. As well as painting in watercolour, Alwyn also works in oil, acrylic and occasionally pastel. He chooses to paint landscapes, seascapes, buildings and anything else that inspires him. Heavy working horses and winter trees are frequently featured in his landscape paintings and may be considered the artist's trademark.

This book is one of eight titles written by Alwyn Crawshaw for the HarperCollins *Learn to Paint* series. Alwyn's other books for HarperCollins include: *The Artist At Work* (an autobiography of his painting career), *Sketching with Alwyn Crawshaw*, *The Half-Hour Painter*, *Alwyn Crawshaw's Watercolour Painting Course*, *Alwyn Crawshaw's Oil Painting Course*, *Alwyn Crawshaw's Acrylic Painting Course*, *Alwyn & June Crawshaw's Outdoor Painting Course* and *You Can Paint Watercolour*.

Television appearances

To date Alwyn has made eight television series. These include *A Brush with Art*, *Crawshaw Paints on Holiday*, *Crawshaw Paints Oils*, *Crawshaw's Watercolour Studio*, *Crawshaw Paints Acrylics*, *Crawshaw's Sketching & Drawing Course* and *Crawshaw Paints Constable Country*, and for each of these Alwyn has written a book of the same title to accompany the television series. His latest television series, *Crawshaw's Watercolour Cruise*, was filmed in Spain and the Middle East.

Alwyn has been a guest on local and national radio programmes and has appeared on various television programmes. In addition, his television programmes have been shown worldwide, including in the USA and Japan. He has made many successful videos on painting and is also a regular contributor to the *Leisure Painter* magazine and the *International Artist* magazine. Alwyn and June organize their own successful and very popular painting courses and holidays.

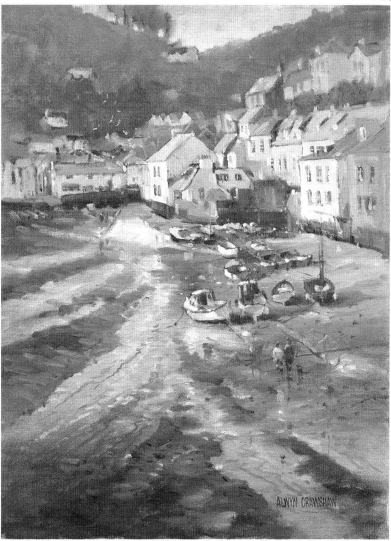

They also co-founded the Society of Amateur Artists, of which Alwyn is President.

Alwyn's paintings are sold in British and overseas galleries and can be found in private collections throughout the world. His work has been favourably reviewed by the critics. *The Telegraph Weekend Magazine* reported him to be 'a landscape painter of considerable expertise' and the *Artists and Illustrators* magazine described him as 'outspoken about the importance of maintaining traditional values in the teaching of art'.

▲ **Polperro, Cornwall**
oil on canvas
40 x 30 cm (16 x 12 in)

Why Paint Landscapes?

It is not hard to understand why so many artists over the centuries have painted landscapes. As a subject for painting, landscape is never ending – there is always something to see and paint. You can stand in the countryside on the same spot and from each of the four compass points see a different picture. Now add to that a sunrise, sunset, daytime, night-time, a sunny day, a windy day, a rainy day, a misty day and so on. Then add the four seasons of the year to the permutation. You can see that from just one viewpoint you can paint dozens of different pictures during the year.

Not only are there always subjects for the landscape painter to paint, but there is also the call of the 'great outdoors'. At times we all have the feeling of wanting to get outside. We have the urge to get close to nature: to see the vast landscape in front of us with windswept clouds, or the tree fallen half across an old cart track that has long since had its last horse and cart rumbling down its rutted surface.

A sense of inspiration

All our senses, not just our visual sense, are with us whenever we are outside. Our sense of touch allows us to feel the wind, the warmth of the sun or the sting of nettles. Our sense of hearing also plays a big part in enjoying or 'seeing' the countryside: the birds singing, running water, wind blowing through the trees, and so on. But above all, apart from

▼ **A Soft Blanket of Snow**
watercolour on Bockingford watercolour paper 200 lb Not
38 x 50 cm (15 x 20 in)
My original sketch for this watercolour, although done in winter, was not a snow scene. One of the advantages of working indoors is that you can add details like snow using your memory and imagination. Of course, I have sketched and painted in the snow many times but to get the best results it really does help if you are warm and comfortable!

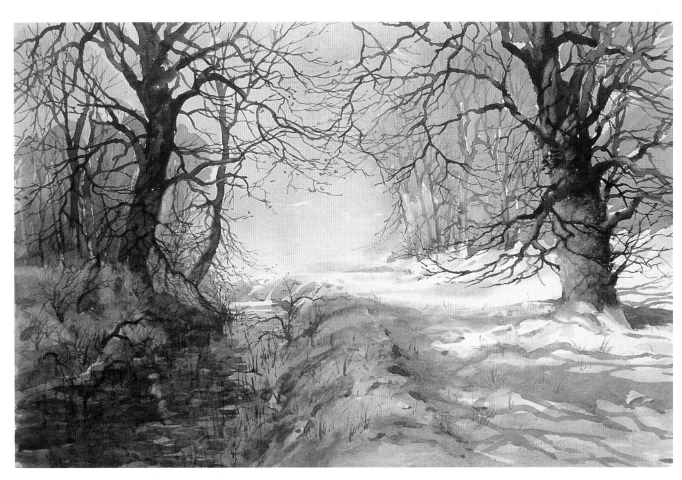

Contents

Portrait of an Artist

Successful painter, author and teacher, Alwyn Crawshaw was born in Mirfield, Yorkshire and studied at Hastings School of Art. He now lives in Norfolk with his wife June, who is also an artist.

Alwyn is a Fellow of the Royal Society of Arts, and a member of the British Watercolour Society and the Society of Equestrian Artists. He is also President of the National Acrylic Painters Association, an

◄ Alwyn Crawshaw working outdoors.

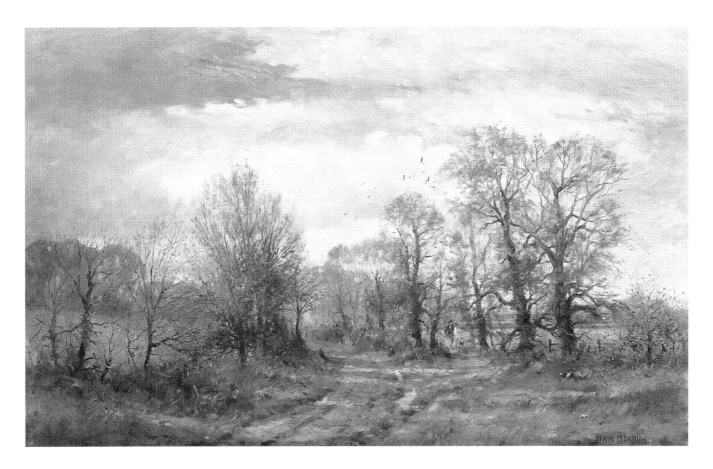

seeing the countryside, the sense of smell gives me the most inspiration for painting landscape: the scent of long, sweet summer grass; the dank aroma of wet autumn leaves; the smell of a dusty road after a quick summer shower of rain.

Painting indoors

Of course, when it's impossible to go out, you can paint indoors from your imagination or sketches you have done outdoors. One great advantage of painting indoors is that it gives you more time to consider the progress of your painting and to change parts of it if you feel that this is necessary. Most of the Old Masters worked outside on smaller studies and then used their sketches for information and inspiration for larger indoor paintings.

Types of sketch

The word 'sketch' can mean many different things from a rough drawing to a finished picture. I believe there are three distinct and very practical types of sketch:

Enjoyment sketch
A drawing or painting worked on location and done simply to enjoy the experience.

Information sketch
A drawing or painting done for the sole purpose of collecting information

Atmosphere sketch
A drawing or painting worked for the sole purpose of getting atmosphere and mood into the finished result. It can then be used at home for atmosphere and mood information, or as an inspiration sketch for an indoor landscape painting.

All sketches, whether they are drawings or paintings, can be used as 'finished' works. In fact, some artists' sketches are preferred to their finished paintings. We will cover the subject of sketching in more depth later in the book.

▲ **Afternoon Walk with the Dogs**
oil on canvas
50 x 75 cm (20 x 30 in)
This oil painting was also done at home using a location pencil sketch. Because you haven't got colours to copy from when working from such a sketch, I suggest you also take a photo of the scene to guide you. As you progress and gain experience, you will find your visual memory helps you to remember colours when you work indoors.

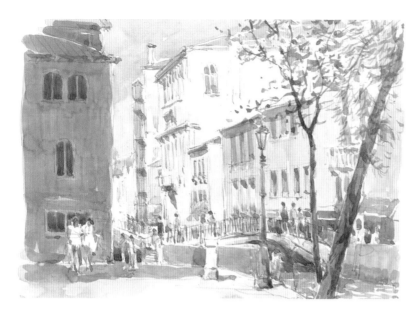

▲ Venetian Canal
2B pencil and watercolour
on cartridge paper
20 x 28 cm (8 x11 in)
It was a gorgeous day and
I was sitting comfortably
on a bench by the side of
the canal when I painted
this scene. The air was full
of the sounds of lapping
water, boatmen calling
and holidaymakers
enjoying themselves.

Get out and about!

The true inspiration for landscape artists is
Mother Nature. Never forget this. Try to go out
and paint as much as possible. Observe – even
when you are a passenger in a car or train, look
at what you see with the object of painting it.

Art school taught me to observe and
translate what I saw into a painting (in my
mind!), and I am still doing this. I could be
walking and talking with my family about
anything other than painting, when I stop and
say with great excitement: 'Look at that – isn't it
fantastic? It would make a perfect watercolour
or oil painting', or whichever medium suited
the scene.

Carry a sketchbook

When you are out, carry a small sketchbook
with you. If you have time on your hands, start
drawing. If you are aware of wanting to sketch,
you will find plenty of opportunities coming
your way. If they don't, put a little pressure on
yourself and make some – where there's a will,
there's a sketch!

I wrote this book to help you to paint
landscapes and, to do this, I decided to work
in watercolour and oil. If you want to learn
more about these mediums, three of my
books in this series cover each medium in
great detail. These are: *Learn to Paint
Watercolours*, *Learn to Paint Outdoors in
Watercolour* and *Learn to Paint Oils for
the Beginner*.

In the following lessons and exercises there
is no underlying reason why a painting is done
in watercolour or oil. If there is any specific
reason, it is that I feel the subject matter is
more suited to that particular medium.

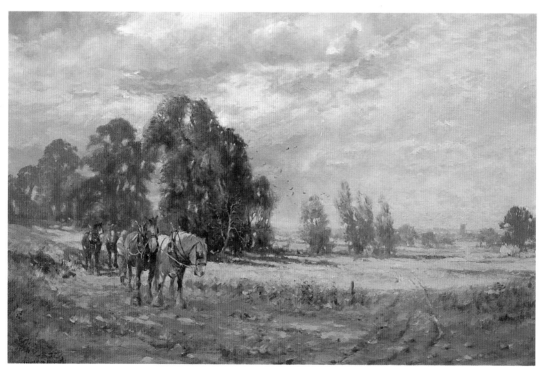

**◄ 'You Are Always
Watching the Birds!'**
Oil on canvas
60 x 91 cm (24 x 36 in)
I used my pencil sketches
of horses done at horse
shows for this painting
but the landscape was
pure imagination!
Working on an oil this size
gives you plenty of time to
rethink areas that are not
working out – something
that is very difficult and
often impossible to do
with a watercolour.

Above all, enjoy yourself

When you are out painting, try not to become too obsessed with your work or you will miss the joy of being outside and painting. Whatever you do, make your painting enjoyable. There are going to be times when nothing goes right and you will blame everything from your paintbrush to the weather. This happens to all of us, but remember that whatever you put down on paper when working directly from nature is spontaneous, and something will always be learned, no matter how brief the encounter. Never throw away a poor sketch or painting; every picture tells a story. Even if it says: 'Don't do it this way again!', it will serve as a constant reminder to you!

Before you are tempted to start painting, I would like you to relax and to carry on reading this book. I will take you through things stage by stage, working very simply to start with, and then progressing to a more mature form of painting. When you do start the lessons and exercises, enjoy them. If you find some parts difficult, don't get obsessed with the problem. Go on a stage further and then come back – seeing the problem with a fresh eye will make it easier to solve.

I did the impromptu enjoyment sketch (above) when June and I were cruising with our friends on the river near where we live. As we passed the buildings and boatyards, I looked behind me, saw the scene and was inspired! We were moving very slowly, so I had ten minutes to sketch before the view was too far into the distance. Standing while holding my sketchpad, combined with the movement of the boat, made drawing clean, definite lines almost impossible but I was very pleased with the result and, more than that, I had just enjoyed one of those memorable moments that the landscape painter lives for – to see a scene, to be inspired, to sketch or paint it, and to feel really contented.

Start simply

If you are a beginner, don't attempt anything too ambitious to start with. To have spirit and determination is fine, but to try for the unattainable and then fail to reach your desired goal could ruin your confidence and put you back a long way. But if you have a go at a simple subject, and it comes off, this will boost your confidence enormously. Remember the old saying: 'Don't run before you can walk'. Good luck!

▲ **The Swan Hotel, Horning, Norfolk Broads**
2B pencil on cartridge paper
20 x 28 cm (8 x 11 in)

Watercolour Equipment

Crimson Alizarin

Yellow Ochre

French Ultramarine

Cadmium Red

Cadmium Yellow Pale

Coeruleum

Hooker's Green
Dark

▲ These are the
watercolours I have used
in this book.

All professional artists have their own preferences regarding the materials they use: brushes, colours, paper and so on. In the end, the choice must be left to you to make from your personal experience but, to get the best results, buy the best materials you can afford. If you are a beginner, I would suggest you use the materials I have used throughout this book. I have kept them simple and uncomplicated to help you. Incidentally, I use these same materials for all my watercolour painting.

Colours

There are two qualities of watercolour paints. The best ones are called artists' quality, while the less expensive ones are called students' quality. Daler-Rowney manufacture Aquafine Georgian watercolours, which are an excellent student quality.

Colours come in tubes or pans but I suggest that you use pans to start with – it is much easier to control the amount of paint you can get on your brush than from paint squeezed out of a tube onto a palette. Pans come in paint boxes and you use the lid of the box as your palette, see mine (top right). I use pans for all my work. The colours I normally use and have used in this book are shown (left) and I will show you in more detail about colours and colour mixing on page 12.

Brushes

Brushes are the tools of the trade. Like a pen with handwriting, they show the difference between one person's work and another. It is the brushes that make the marks that make the painting. They are so important! Brushes made from sable hair are the best quality you can buy for watercolour. Brushes made with man-made fibres (Dalon is the brand name for an excellent range of brushes used by professionals and amateurs) are less expensive. Another good range of brushes is Expression; this is a mix of red sable and synthetic filaments. These are more expensive

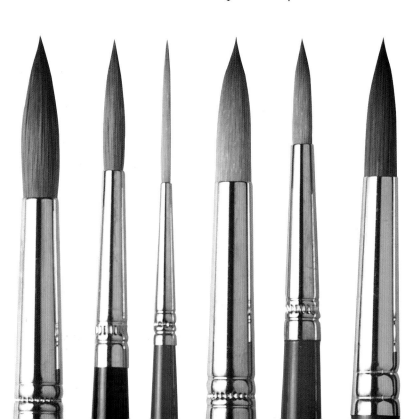

◄ There are many different types of brushes, but here are some that I strongly recommend. From left to right (actual size): Series 40 Kolinsky sable round brush No. 10; Series 43 sable round brush No. 6; Series D99 rigger brush No. 2; Series D77 round brush No. 10; Series D77 round brush No.6; Series E85 Expression round brush No. 10.

than the Dalon brand. I use three brushes. These are a Daler-Rowney Series 40 round sable No. 10 (my 'big brush'), a Series 43 round sable No. 6, and a Dalon Series D99 rigger brush No. 2, which I use for small 'line' work. It is ideal for tree branches. A selection of brushes that I recommend are shown (below left) but at first you only need one No. 10 and one No. 6, plus a rigger.

▲ My watercolour box

Paper

I have used three different types of paper in this book, but the one I have used the most, an excellent and inexpensive one, is Bockingford watercolour paper 200 lb Not. The word 'Not' describes the surface and it means it is not a rough surface. The weight of the paper (200 lb), denotes the thickness of the paper. If the paper had a rough surface, it would show the word 'Rough' after the weight, e.g. Bockingford watercolour paper 200 lb Rough. This applies to almost all watercolour papers. Another excellent paper is Waterford. This has a harder surface than Bockingford and allows you to paint more washes over washes without disturbing the dry wash underneath. Finally, cartridge drawing paper is very good for painting on. I often use it for small (up to A3 size) outdoor work. It has only one surface, which is smooth. You will find out what each paper offers you only through practice and experimenting. All these papers can be bought by the sheet, 50 x 75 cm (20 x 30 in), or in smaller books or pads.

Other materials

Whether or not you use an easel is up to you. I don't use one. When I am working outdoors, I rest my pad or board (with my paper pinned to it) on my knees. When indoors, I work on a table. You will definitely need a putty eraser, a water holder and, finally, a 2B and a 3B pencil. Naturally, as you progress and become more experienced, you will want to try different colours, different papers and other brushes. This can be very exciting but, for the moment, try to be patient!

◀ The three types of paper I have used in this book for watercolour are (from the top): Bockingford watercolour paper 200 lb Not; cartridge drawing paper, and Waterford watercolour paper 200 lb Not.

Colour Mixing in Watercolour

If you are a beginner, I know this chapter on mixing colours will be very exciting, and – better still – easier than you think. If you have painted before, use it as an excuse to get back to basics; to experiment and enjoy a fresh and exciting journey around your paintbox.

Primary colours

There are countless colours in a landscape, but you can get almost any colour you need from just the three primary colours: red, yellow and blue. There are different reds, yellows and blues to help you mix the colours you want, but generally you should be able to paint a picture using just one of each of the primary colours.

Although there are three primary colours, many colours that we make are mixed from just two. For instance, green is mixed from yellow and blue. If you want a warmer (browner) green, you will need to add a little of the third primary colour, red, to your mix. This is where colour mixing gets slightly more complicated – for instance, if you tried to get the warm green by mixing equal parts of yellow, blue and red, you would make a dark mud colour!

So how do you judge the correct quantity to mix to get the desired colour? You will discover this by practising but always remember this: the first colour you put onto your mixing area must be the predominant colour you are trying to create. For example, if you want to mix, say, a reddish-orange, you should put red into the mixing area because red is the predominant colour, and then add a smaller amount of yellow. If you start with yellow in the mixing area and then add a smaller amount of red, you will make a yellowish-orange. You could eventually get a reddish-orange by adding more and more red, but you would mix more paint than you needed, and it would be very frustrating and time-wasting. To make your colours lighter, add water to the paint.

Local colours

Although you can paint a picture using three primary colours, a good reason for having different primaries is to be able to use them for local colours. A local colour is the colour of an individual object: for example, a particular red car, blue boat, yellow flower, etc.

Using the right colour is important when you are painting a picture but don't worry about it or keep re-mixing if your colour is a little different from the real-life colour. You don't have to be exact. Everyone can learn to mix colours. Keep practising – you will experience a wonderful feeling of success when you are able to mix the colours you need.

Always note the first colour shown on the exercise or specified in the text when you are mixing colours. This is usually the predominant colour of the mix, with other colours added in smaller amounts.

You may have noticed that my palette doesn't include black. Some artists use black, others don't. I am one of those who doesn't. I believe it is too flat – a dead colour, in fact – so I mix my blacks from the primary colours.

Relax when you are learning to mix colours and you will get better results. It doesn't matter what the result looks like – it's only practice.

▶ Watercolour painting colour mixing chart

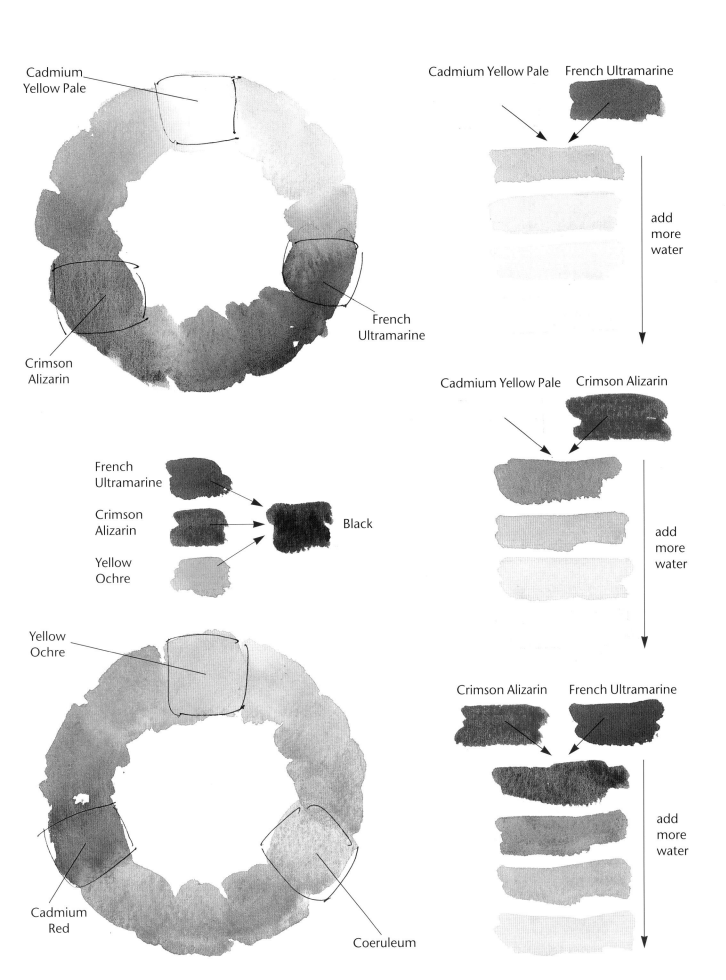

Cadmium
Yellow Pale

Crimson
Alizarin

French
Ultramarine

French
Ultramarine

Crimson
Alizarin

Yellow
Ochre

Black

Yellow
Ochre

Cadmium
Red

Coeruleum

Cadmium Yellow Pale French Ultramarine

add
more
water

Cadmium Yellow Pale Crimson Alizarin

add
more
water

Crimson Alizarin French Ultramarine

add
more
water

Watercolour Techniques

If you haven't painted in watercolour before, here are some basic principles to get you started. First of all, remember that watercolour is transparent, and therefore the background surface (paper or paint) shows through. Always start by painting lighter colours first.

As you progress through the picture, build up your dark areas by painting darker tones over lighter tones, when they are dry. Because it is transparent, you can't make a dark colour lighter by painting a lighter colour over it. Your light colours or light areas in a painting are left either as unpainted white paper, or simply by lighter tones that have not been made darker by adding more paint on top.

Follow the arrows

On these pages, I have shown some very basic watercolour techniques and where I have used these techniques in paintings. I have used two types of arrow in various places in this book to help you understand the movement of the brush strokes. The red arrow shows the direction of the brush stroke, and the blue

When working indoors, you can dry the paint with a hairdryer. Hold it 45 cm (18 in) away to start with, then closer as the paint is drying.

arrow indicates the movement of the brush in relation to the paper – from top to bottom or bottom to top.

Painting a wash

The secret is to use plenty of water when you paint a wash (below left). Take the loaded brush from left to right in one stroke. Continue from the left again, letting the first stroke run into the second and so on down the paper. When working in watercolour, your painting surface must always be at an angle, to allow the paint to run down the paper.

▼ I used washes for the sky and the shadows on the snow under the trees.

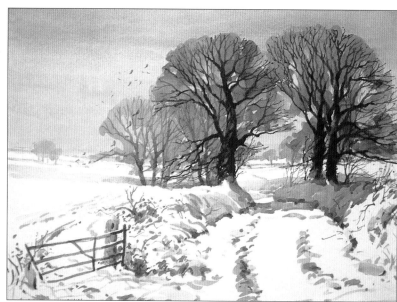

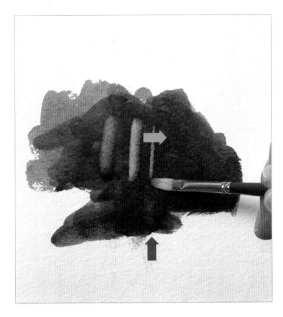

Lifting out

You can lift out with a paper tissue, a sable, Dalon or Bristlewhite brush (above). The stiffer the bristles of your brush, the more paint you will be able to lift out with it.

Wet-on-wet

If you add another colour into the paint while it is wet, the two colours will mix and merge. This technique is called 'wet-on-wet' (below). Once the paint has started to dry on your painting surface, don't apply any more paint on it, or you will get some very strange effects (although you might choose to experiment with and use these when you have plenty of experience!).

Once the paint is completely dry, you can apply another colour on top of it. Then the colours will not mix and hard edges will be created. The wet-on-wet technique is used throughout a watercolour painting.

There are many more subtle watercolour effects – the most exciting ones will be those you create for yourself as you gain experience. By using these, your paintings will become very much your own.

▲ The tree trunks and some branches were made lighter by lifting out with a Bristlewhite brush.

▼ The wet-on-wet technique was used here to create the stormy sky.

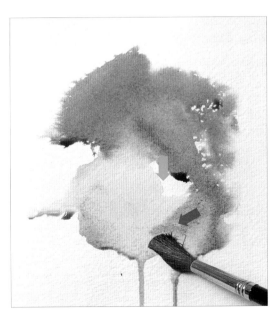

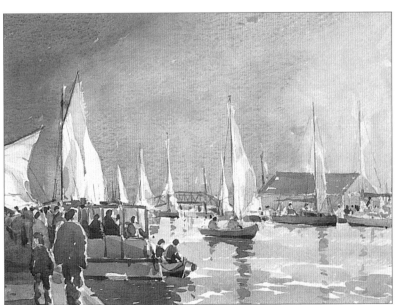

Oil Equipment

As with watercolour materials, oil painting materials are the choice of the individual artist. But use the ones I have used for this book and it will be less complicated and easier to follow, especially with so many different brushes, paints, mediums and painting surfaces (grounds) on the market today. Remember, you can always add to or subtract from these materials when you gain more experience.

Colours

All oil colours come in tubes and small amounts are squeezed out onto an artist's palette. Like watercolour, there are artists' quality and students' quality. I have used Georgian oil colours, a students' quality, throughout the book and I am sure you will find them excellent.

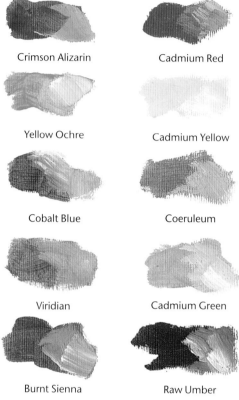

Crimson Alizarin Cadmium Red

Yellow Ochre Cadmium Yellow

Cobalt Blue Coeruleum

Viridian Cadmium Green

Burnt Sienna Raw Umber

◀ These ten oil colours, together with Titanium White, are the ones I have used in this book.

I explain about colour mixing in oil on page 18, and the colours I used for this book are illustrated above.

Brushes

As I said earlier, the brushes make the marks on the canvas, so the choice of brush is very important. The traditional oil painting brush is usually made from hog bristle, but today man-made fibres (nylon) are used – not necessarily to replace the hog bristles, but to allow the artist more scope. There are three basic brush shapes: round, filbert and flat. I prefer to use a flat one for general work, a

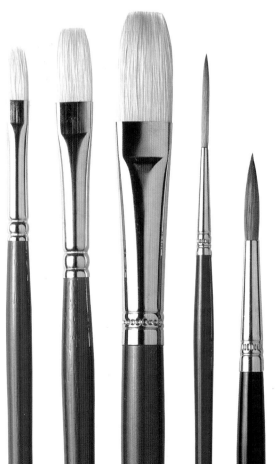

◀ These are the brushes I have used for the book (from left to right): Daler-Rowney Bristlewhite Series B48; sizes 2, 4 and 8; Series D99 rigger No. 2; Series 43 sable No. 6.

small round sable or Dalon brush for detail work, and a 'rigger' for line work. The brushes I have used for the book are illustrated (below left).

Painting surfaces

The traditional painting surface (support) for oil painting is canvas but over the years new surfaces have emerged which are cheaper and allow the artist more choice. Some of the surfaces I have used in the book are reproduced actual size (right), and I have applied some paint to help show you the grain of each surface. Unless the support has been primed by the manufacturer, you should prime all surfaces, especially absorbent ones like paper or MDF, with two or three coats of Gesso Primer or Acrylic Primer. I use all of the surfaces illustrated. Experiment and find the one that suits you and your pocket. Of them all, canvas is usually the most expensive.

Mediums

Don't be concerned about all the different mediums there are for oil painting on the market. We will keep it simple. You want a general purpose cleaner for your brushes and palette. Use turpentine substitute or white spirit. For mixing with your paints to thin the paint as you use it, use Daler-Rowney Low Odour Thinners; this is excellent and it doesn't smell. To make the paint dry more quickly, I use Alkyd Medium. As white paint is mixed with most colours, I add some Alkyd Medium into my white with a palette knife before I start painting. The white then becomes a general drying agent.

Other materials

A lightweight easel is the best one for outdoor work and can also be used indoors. If you don't have an easel to start with, use a kitchen chair. Rest your canvas against the backrest and use the seat to put your paints on. Manufactured artists' palettes can be made of

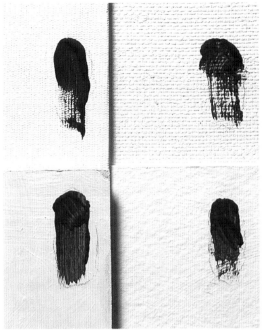

◄ Some oil painting surfaces (supports): top left: canvas panel, medium grain; top right: canvas; bottom left: primed MDF; bottom right: primed Waterford watercolour paper 300 lb Rough.

wood or plastic, and you can use either. You will need a palette knife for mixing or cleaning your palette, and plenty of rags to clean your brushes and the mixing area of your palette after use. A carrying box is good for keeping everything in and also ideal for outdoor work – you can sit with it on your knees with the painting board held in the lid.

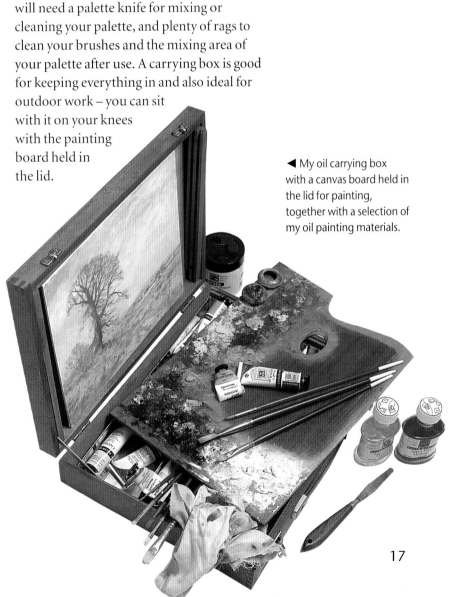

◄ My oil carrying box with a canvas board held in the lid for painting, together with a selection of my oil painting materials.

Colour Mixing in Oil

Naturally, most of the principles for mixing colours with oil paint are the same as for watercolour. If you haven't read the chapter on mixing colours in watercolour on page 12, please read it now before you continue with this chapter.

Important differences

The most important difference between the two is the medium itself. When a brush loaded with watercolour paint is dipped into another colour on the palette, the two colours mix together in seconds. Also, it is the amount of water that makes the paint lighter. It is just the opposite with oil.

With oil, when a brush full of paint is added to another colour on the palette, nothing happens. The two paints have to be physically mixed together with the brush to mix the colours. If the paint needs to be made lighter, this is done by adding white paint and mixing instead of diluting with water. Therefore the process of colour mixing is slower with oil than it is with watercolour.

Because of this, I use more colours when working in oil than I do in my watercolour painting. It can help to make a short cut to

making a colour, also the ready-mixed colour could be cleaner and fresher than the one I would mix with dirty brushes.

Naturally, the three primary colours are still the same, with different reds, yellows and blues. I suggest you start by mixing from the three primaries first and use the colours I have used for the exercises in this book. Then, as you gain experience, gradually add more colours to your palette.

If you are mixing a pale colour, before you put the predominant colour down on your palette you must put white first and then mix in the other colours.

Practise copying colours

Look around at objects in the room and try to copy the colours. Don't mix too much colour, only enough to paint an area of about 7 x 7 cm (3 x 3 in). Remember that a colour changes slightly when it is placed against another colour. For instance, if you were to paint the colour of your curtains onto your white canvas, it could look different to the actual curtain colour. However, if you then painted in the wall colour that the curtain is resting against onto your canvas, you would find that the colour looked more accurate.

Mixing 'black'

I don't use black with my oil paints, for the same reason that I don't use it for watercolour. My 'blacks' are mixed from the three primary colours.

Practise your mixing – you will get a tremendous thrill when you achieve the colours you were trying for. You won't be able to paint a picture, no matter how small, without mixing colours, so you will get better with every painting you do.

Always squeeze your colours onto your palette in the same place. Then you will know where to reach for the right colour every time.

► Oil painting colour mixing chart.

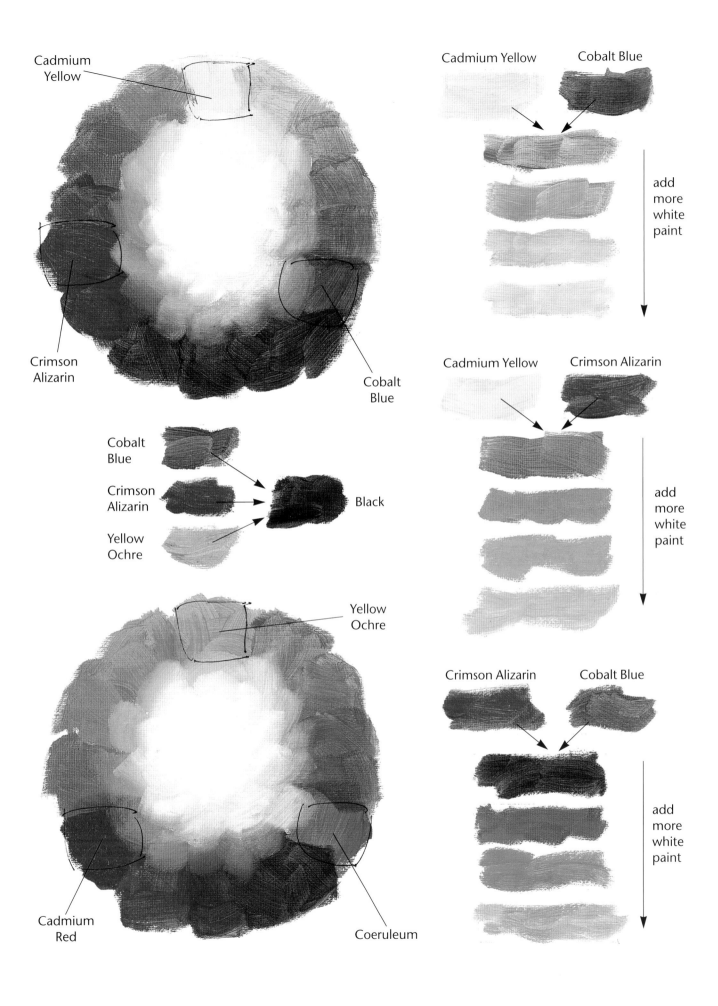

Cadmium Yellow

Crimson Alizarin

Cobalt Blue

Cobalt Blue

Crimson Alizarin

Yellow Ochre

Black

Yellow Ochre

Cadmium Red

Coeruleum

Cadmium Yellow

Cobalt Blue

add more white paint

Cadmium Yellow

Crimson Alizarin

add more white paint

Crimson Alizarin

Cobalt Blue

add more white paint

Oil Techniques

The rules of nature in landscape painting are the same whichever medium you use, but the medium can often dictate which scene you paint. Oil painting is more complicated for working outside than watercolour, because of the equipment needed. But it can be more relaxing, with more time to think and enjoy the subject – and no worrying about a watercolour wash that's running out of control! By the way, I like both mediums equally.

Don't be afraid to change part of an oil painting that has gone wrong. Simply wipe it out with a rag and start again.

Opaque colours

Oil painting is the opposite to watercolour: you work from light to dark in watercolour, but from dark to light in oil painting. You can do this because the colours are opaque and you can paint a light colour over a dark colour and the light colour will 'cover' the dark one up.

To make a colour lighter, you add white paint. Naturally, during a painting you will find the process changes to get particular effects but, in general, work the painting from dark to light. I use Alkyd Medium to help the paint to dry quicker – this is ideal, especially for working outdoors. As I did with watercolour, I have shown you some basic oil techniques on these pages.

A turpsy mix

I usually start my oil paintings by drawing the picture with a No. 6 sable brush, using

▼ A painting can be drawn with a turpsy mix before oil colour is applied.

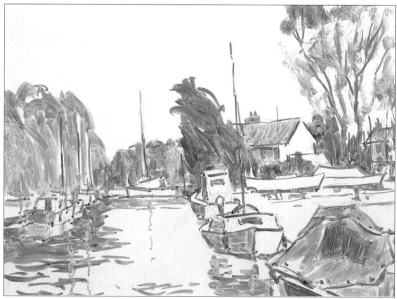

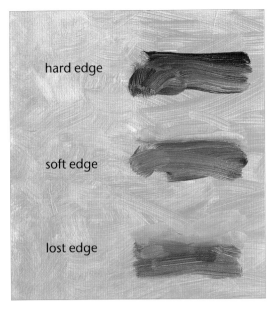

Labels on image: hard edge, soft edge, lost edge

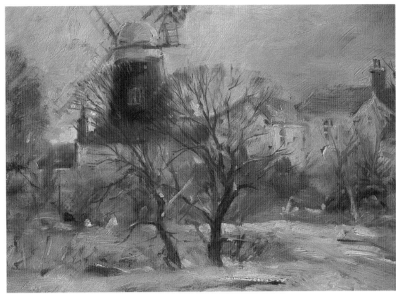

Cobalt Blue and a little Crimson Alizarin mixed with plenty of low odour thinners to make a turpsy mix which can be applied like watercolour.

When I have drawn the picture, I then continue to paint in the dark areas and middle tones with the same turpsy mix, leaving the white canvas as the lightest areas. This gives me the tonal areas and dimension to the painting. When this is dry (this takes about 20 minutes) I start the painting in colour. Always work paint thinly at first and apply it more thickly as you progress through your painting.

Painting edges

This is important. A 'hard edge' makes a shape or part of a shape very clear. A 'soft edge' gives a feeling of softness and distance. A 'lost edge' loses its shape and leaves things to the viewer's imagination.

Thick paint

In most cases, I suggest that you leave your thickest, juiciest paint until last. Doing this can give a wonderful feeling of strength and dimension to a painting.

▲ Look closely at this painting to see all the different edges. With experience, you will learn how to use these edges in your paintings without thinking.

▼ Thick paint gives a three-dimensional look to areas of a painting, making it come to life.

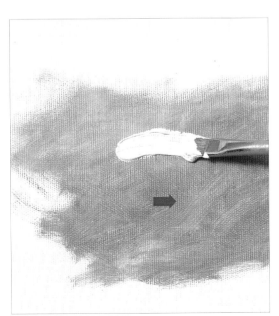

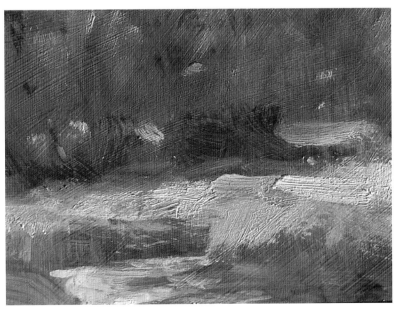

Simple Perspective

Your next step before you start landscape painting should be to take some time to practise simple perspective. If you think you can't draw, don't let this worry you. Some artists can paint a picture of a scene but would have difficulty in drawing it in pencil. However, although broad masses of colour, shapes and tones can make a wonderful painting, if you want more detail in a picture you will need more drawing ability, and this can only be achieved by practice. Those of you who have not painted before will still be familiar with the terms: horizon, eye level and vanishing point; but now let us see how we use them in drawing.

Finding your eye level

When you look out to sea, the horizon will always be at your eye level, even if you climb a cliff or lie flat on the sand. So the horizon is the eye level (EL). If you are in a room, although there is no horizon, you still have an eye level. To find this, hold your pencil horizontally in front of your eyes at arm's length and your eye level is where the pencil hits the opposite wall. If two parallel lines were marked out on the ground and extended to the horizon, they would come together at what is called the vanishing point (VP). This is why railway lines appear to get closer together and to finally meet in the distance – they have met at the vanishing point. On the opposite page, I have drawn a red line to represent eye level.

I have also drawn a red square and, to make this into a box drawn in perspective, I have put the vanishing point on the right. With a ruler, I then drew lines from the two right-hand corners converging at the VP. This gave me the side of the box. Look at the two blue squares above this. Here, I have done the same, but also drawn lines from the left-hand corners of the square. I then drew a square parallel to the front of the box and kept it within the VP guidelines and this created the other end of the box. I repeated this for the green squares.

Remember, anything above your EL you see underneath it (the blue boxes), anything below the EL you see on top of it (the green boxes). This is very important. Although the boxes are drawn in the same way, by adding some simple pencil shading they have become three-dimensional forms, except for the top blue one with no shading, and that gives the illusion of a transparent box.

Putting clouds in perspective

In the same way, clouds can be drawn in perspective in a very simplified way – see my examples (opposite, top right). Naturally you won't be drawing clouds in quite this way, but seeing what happens with perspective will help you draw clouds with greater understanding.

Don't get too tied down with perspective, nature will help when you are outdoors. Remember, observe and practise.

▲ To help you remember perspective, hold a coin horizontally in front of your eyes (EL) and you will only see a straight line. Move the coin upwards (above your EL) and you will see underneath it. Move the coin down (below your EL) and you will see on top of it.

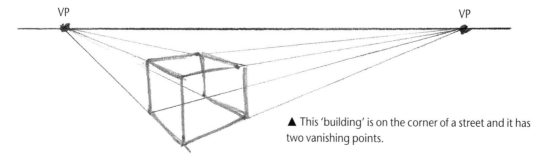

VP VP

▲ This 'building' is on the corner of a street and it has two vanishing points.

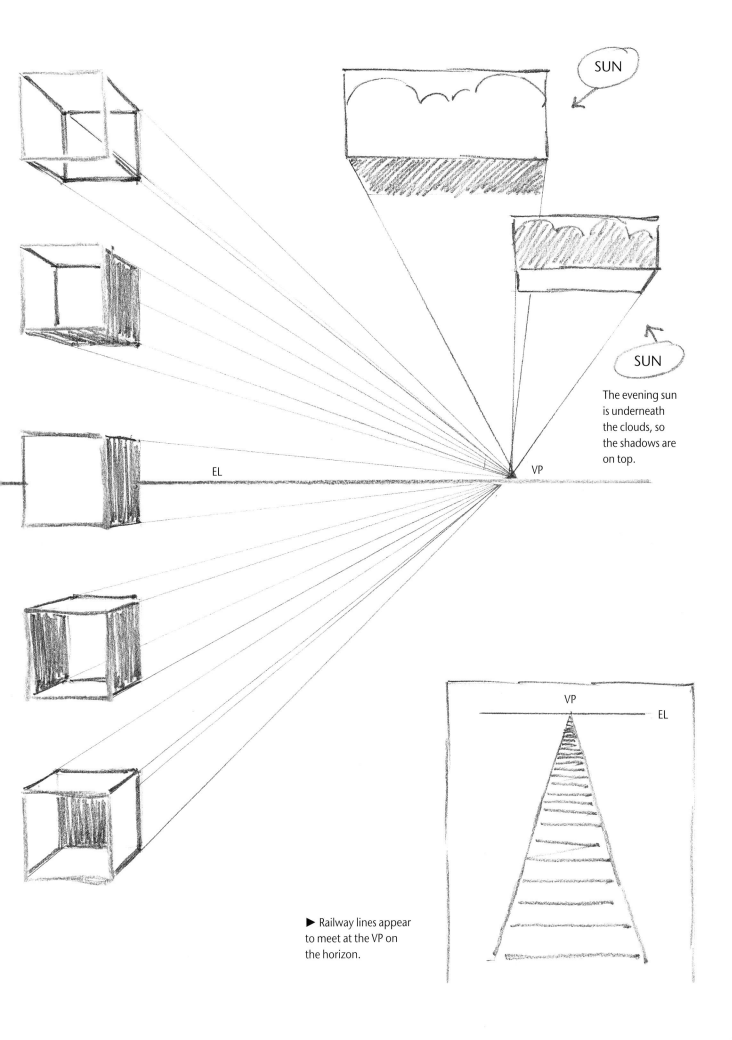

SUN

SUN

The evening sun is underneath the clouds, so the shadows are on top.

EL

VP

VP

EL

▶ Railway lines appear to meet at the VP on the horizon.

Shape and Form

a

light source

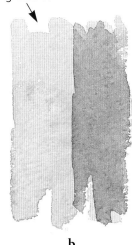

b

This is perhaps one of the most important lessons to learn in this book: how to create the illusion of a 3D object, which actually looks three-dimensional on a flat surface, i.e. your paper. To do this, we use light and shade (light against dark, dark against light).

Look at the examples on this page. In **a**, I have painted a small wash. But it is shapeless and meaningless. In example **b**, I give it a light source and a shape starts to emerge.

In **c**, I have gone one step further and drawn a pencil line around the shape to represent a box. The top is lightest where the light source is strongest. The left side of the box is lighter than the right side, which is in strong shadow and therefore the darkest. So the 'form' of the box is created by light against dark. The top edge of the box is created by the pencil line which is darker than the paper background. The front side is darker than the paper on the left, and lighter against the darkest right-hand side of the box. Therefore, only through light and shade (light against dark, dark against light) has the box shape been created, giving a 3D

illusion. Naturally this applies not only to landscape but to everything we paint.

In example **d**, the box is the same as **c**, but on a dark background. The background is darker than the darkest side of the box, therefore it is a light box against dark. But the box in **c** is a dark box against light (a white paper background).

Lost and found edges

When we look at a landscape, our eyes can't see everything with crystal clarity. Some objects have clear hard edges, while others have soft edges, and ones that you can't even make out. We call these 'lost and found' edges. A hard edge always stands out, while a soft edge or lost edge will recede. This helps to give dimension and depth to a painting.

If you look carefully at **e**, the background is the same tone as the darkest side of the box and, therefore, the edge disappears. This is a lost edge, but you can still recognise the shape as a box. This adds a little visual mystery which can be an asset in a painting.

d

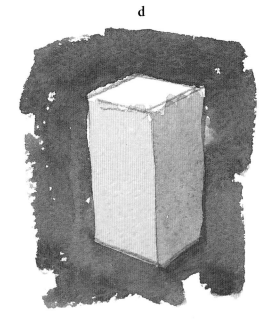

e

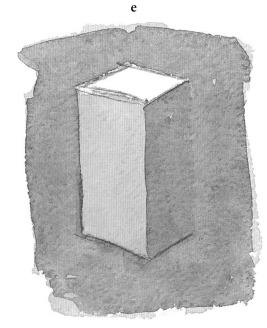

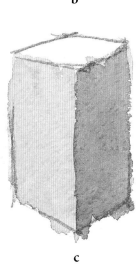

c

Shadows

Shadows are very important for the landscape painter. They show form and shape and can give a large distant landscape a far more interesting and dynamic look, when the shadows (from clouds) are falling on distant fields or mountains and contrasting against the brightness of the sunlit areas. Remember, you only see them because they are dark against light. The foreground is also helped with shadows.

Never be afraid to put shadows in. Be positive – they will always help to create atmosphere and give shape and form to your landscapes.

◄ Here, the snow foreground is left as white paper, but it has no form or dimension.

◄ As soon as a shadow is cast on the snow, it shows the contours of the snow and gives the white paper meaning. In this case, the shadow gives the impression of the snow being flat.

◄ A shadow can transform the snow from flat to uneven, and this is achieved without painting any other tonal effects in the snow. Usually the stronger the sun, the darker the shadow.

Painting Skies

We are now ready – if you have practised mixing colours – to try some simple exercises. These are to be treated in broad terms; don't try to put much detail into them. Copying them will make you more familiar with the subject when you paint out-of-doors.

Gaining in confidence

I can't stress too much the importance of being familiar with your brushes, paints, colour mixing and, finally, your subject matter. The more you know about all these, the more confidence you will have – and the better your paintings will be.

I have taken the four main ingredients of landscape – sky, trees, water, and ground – for the purpose of some simple exercises, starting here with the sky. Some of these exercises were done in watercolour and some in oil, but the general teaching applies to each subject. If I have worked an exercise in watercolour, do have a go with oil. Remember that the object of these lessons is to practise and to learn.

So, let us consider the sky. Whatever type of landscape you paint, the sky – to my mind – plays the most important role. It is the sky that conveys to us the type of day it is, whether it is sunny, cold, blustery, rainy, etc. Even from indoors, one look at the sky can usually indicate what it is like outside.

The sky is the all-embracing mood in which the landscape sits. If this mood is captured, it will follow naturally through to the rest of the painting. As I said earlier, our senses help us to keep the mood of a painting alive. If you paint a sky with feeling and atmosphere, you can go on to paint a masterpiece. If your sky hasn't got atmosphere or feeling, that landscape can never become your best work.

▼ I painted this sky with my No. 10 sable brush on Bockingford watercolour paper 200 lb Not, measuring 17 x 33 cm (7 x13 in). It makes three important points. Firstly, I have used strong perspective for the clouds. This gives distance. Secondly, I have only used one wash of different colours, wet-on-wet. This simplifies the sky. Finally, when this was dry, I painted a suggestion of landscape to give scale.

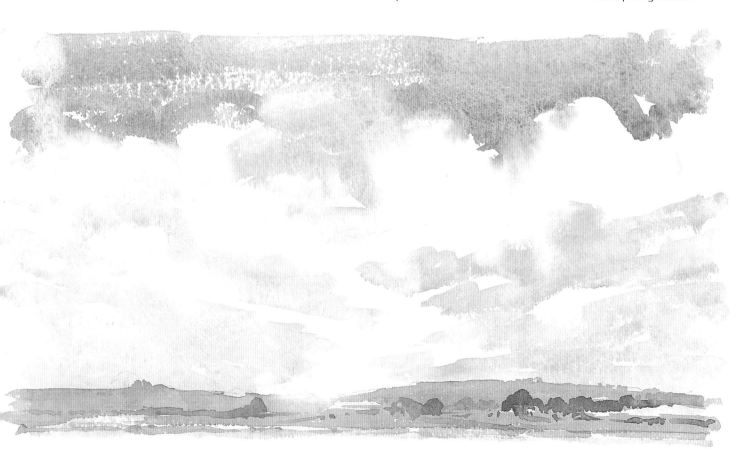

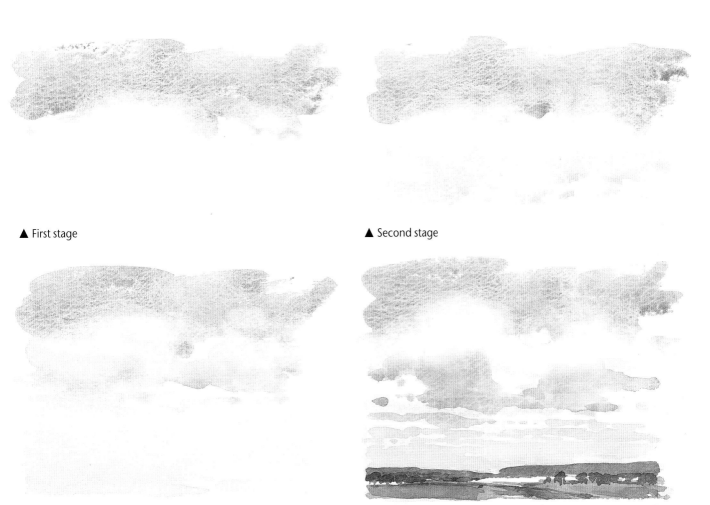

▲ First stage

▲ Second stage

▲ Third stage

▲ Finished stage

Paint a simple sky

For this exercise, I used Bockingford watercolour paper 200 lb Not, and painted it twice the size it is reproduced here. Be warned, you can't copy mine exactly. It's impossible – I couldn't! So if your paint runs a different way to mine and it looks good, keep it. That is watercolour! Relax and enjoy it.

First stage
Using your No. 10 brush, paint the blue sky with French Ultramarine. While it is still wet, paint some water up into the blue to create soft edges.

Second stage
Now mix Yellow Ochre and Crimson Alizarin and paint it into the wet areas, letting the paint mix. Finally, paint in some horizontal brush strokes of paler (add water) French Ultramarine under the clouds.

Third stage
While this is wet, paint into it a mix of Crimson Alizarin and Yellow Ochre and paint down to the horizon. Then continue but add more Yellow Ochre and paint to the bottom of the picture.

Finished stage
The first three stages were all done while the paint was wet. Now let it dry. Then start by wetting the undersides of the clouds and painting dark shadows underneath them. (Use the colours you have been using, but darker.) By starting with water, this softens the edges. Continue with horizontal brush strokes to represent distant clouds. When this is dry, paint in the distant landscape.

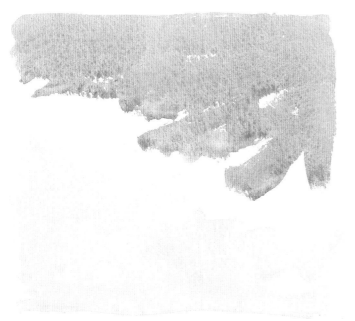

▲ First stage

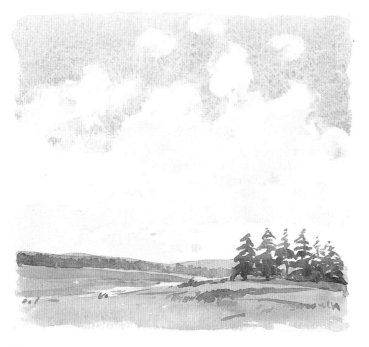

▲ Finished stage

Moving clouds

When you feel you are ready to paint skies out-of-doors from nature, you will find it very confusing because the clouds will not stop for you! Naturally some clouds (those in the distance) appear to move much more slowly than those immediately above us, allowing us to take more time to paint them. But we must accept the fact that the sky moves and we have to paint it while it is moving.

Start by doing pencil sketches – the three types of sketch: enjoyment, information and atmosphere. Keep a sketchbook reserved just for skies because this will become an important source of reference for you. As well as your 2B or 3B pencil, remember your kneadable putty rubber for rubbing out highlights of clouds.

The secret of drawing moving clouds is to look at the sky and watch the pattern of movement. Observe which banks of clouds are going behind others, which are moving

Don't practise on expensive paper – not wanting to spoil it will restrict your freedom and your painting progress will suffer.

Lifting out clouds

For the sky exercise above, I used Bockingford watercolour paper 200 lb Not, measuring 17 x 20 cm (7 x 8 in).

First stage
Start by painting the 'blue' sky, using a mix of French Ultramarine and a little Crimson Alizarin. Then water this mix down and add Yellow Ochre and paint the cloud area. This must be very wet.

Finished stage
Now, using a crumpled tissue, gently blot the blue sky and cloud area to represent clouds. When this is completely dry, add the shadows and paint in the landscape.

fastest, and so on. Here's a good tip. Screw your eyes up (squint) and you will see the mass of shapes in a more simplified pattern. This method of simplifying, which you can use for every subject, should become second nature. When you do this, apart from simplifying shapes, the middle tones disappear and the darks and lights are exaggerated. Practise this – it is as important to you in all your painting as mixing the correct colour.

When you have got the 'feel' of the sky and its movements, wait for a descriptive formation to unfold – look hard at it, hold your breath and off you go!

Start in the middle of the paper, as this will give you room to manoeuvre in any direction, and roughly draw the shapes of the clouds. Then, very broadly, shade in the areas of tone. Depending on the speed of the clouds and your speed, the formation you started with may have changed but, because you have observed the nature of cloud movement you should be capable of a little 'ad libbing'.

Don't try to change it!

Once you have decided upon your sky formation and started, don't try to alter what you have done to look like the changed sky – it will change again and you will be left 'up in the clouds'! If you have to change because the sky has developed into an absolute beauty, then start again on another page. Don't do these sky studies any larger than 20 x 28 cm (8 x 11 in) but you can sketch them as small as 12.5 x 10 cm (5 x 4 in).

When you have gained enough confidence working in pencil, have a go with colour. Incidentally, on all your outdoor sketches, especially skies, make a note of the time of day, position of the sun, type of day and the date. This information will help you to understand the sketch totally at a later date.

One last point. When you paint a sky, add some part of the landscape, even if it is only a line of distant hills. This relates the sky to the ground and gives scale, depth and dimension.

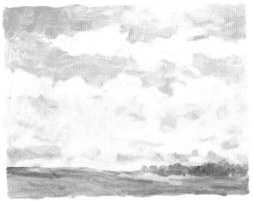

◄ This sky, in oil on fine grain oil sketching paper, 15 x 20 cm (6 x 8 in), gives the illusion of a bright, sunny day with soft, feathery clouds being blown across the sky. The area of bright green against the dark trees, and the pink in the clouds helps to create a sunlit effect.

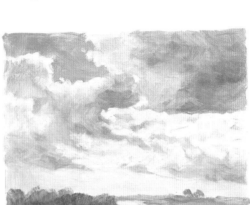

◄ This sky gives a more sombre feel to the landscape. The clouds are heavy and rain is just around the corner. I added a little green to the sky at the horizon, and this has helped to unify the sky and land and keep the mood of the day.

◄ This painting and the one below were painted on primed Waterford watercolour paper 200lb Rough, then given a wash of Acrylic Raw Sienna and Crimson Alizarin. A strong sunset can be very powerful in a painting, but don't overdo it. Understate that breathtaking redness, or it will look unrealistic.

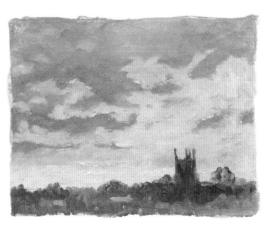

◄ This sky is in total contrast to the one above. The early morning sun is starting to warm the distant sky, the night clouds are drifting away and you can feel the promise of a nice day. Notice how some of the 'red' background wash shows through in places, adding life and interest to this sunrise.

29

Painting Trees

The tree is nature's best gift to the landscape artist when it comes to the composition of a painting. For instance, one lone tree can make a picture. Trees can be used to break the horizon line; they can be positioned to stop the eye going forward or to lead the eye into a picture. Go out on sketching trips and just sketch trees; in fact, keep a small sketchbook for trees, as I suggested you do for skies.

First things first – winter trees

Before you start painting trees, learn to draw them first. If it is the right time of year, find a good-looking tree out of leaf, and make an information sketch of it. Look at the overall shape of the tree to get its character. Draw it as carefully and with as much detail as you can.

The more you work at that sketch, trying to draw every branch, the more you are learning about the tree's form, growth pattern, size, and so on. After you put down your pencil (your fingers and wrist still aching), you will realise just how much you have learned about that one tree. Then use a sable brush and just one colour and do the same exercise with brushwork.

Don't ever worry about the mistakes you make – this is all part of the learning process.

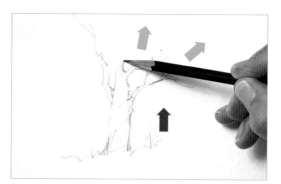

◄ When you draw your trees, always start at the bottom and draw upwards in the direction the trunk and branches grow.

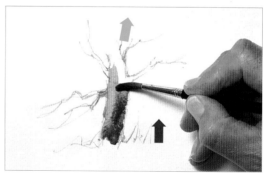

◄ To show sunlight on the trunk, paint a light colour first and, before this dries, add a dark colour. They will merge – wet-on-wet.

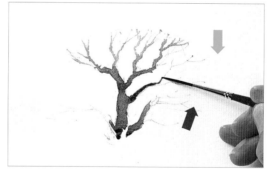

◄ Use your rigger brush to paint the thin branches. Just as you do when drawing with your pencil, work the brush in the direction the branch is growing or going.

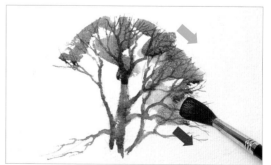

◄ For the feathery branches, use a large brush. Push the brush 'flat' on the paper and move it up and around. Don't worry, you will not hurt the brush!

Paint a tree in watercolour

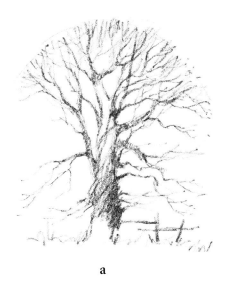

a

In figure **a** (left), I have drawn a tree with my 2B pencil. In **b, c** and **d**, I have painted it as a winter tree using my No. 6 sable brush and my rigger. Finally, using the same pencil drawing and the same brushes, I have painted the tree in leaf (**e, f** and **g**). Practise this exercise – it will give you confidence when you work outdoors. Trees are a very important part of a landscape. If you can, take some photographs of different trees in winter and summer. Use these for reference and copy them for practice. The close-up photographs on the previous page show how particular areas were worked.

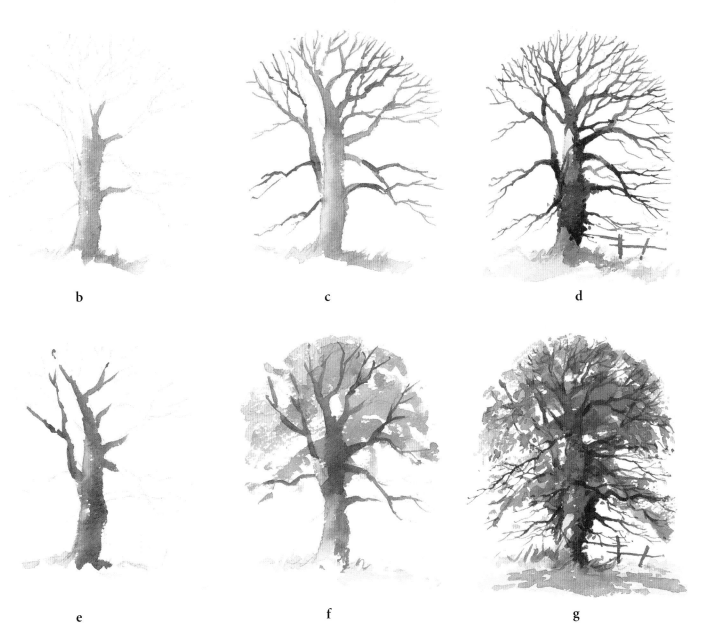

b

c

d

e

f

g

Start sketching trees in leaf

When the leaves come out on the trees, go out and sketch them, again using pencil first.

Work your first sketch of a tree in leaf from a distance of about 275 m (300 yd) From this distance, you will see only the broad shape and character of the tree and you won't be tempted to worry about the detail – you won't see it from that distance! Then sketch from closer positions until you are near enough to make separate studies of areas of branches and leaves in the tree. When you get very close and look into the tree, you will have to screw up your eyes to pick out the shapes you have to draw.

Never make a tree in leaf look like a solid lump of Plasticine! Even if it is a mass of leaves, like a large chestnut can be, there will still be light and shade in the pattern of foliage and in most cases sky will show through in places. Use the 'half-closed eyes' technique to its full advantage and pick out the different tones and shapes of the leaf masses. Shade them in with a 3B pencil and make particular note of the leaves that show dark or light against the sky. These areas give it sparkle and help to identify the species.

Painting leaves

When you feel you are ready to work in paint, work very broadly to start with, looking for the large mass areas of leaves first, then break those areas down into smaller areas of shape, colour and tone. Start again from about 275 m (300 yd) and work closer as you gain confidence. Don't put too much detail into trees in the middle distance or you will find them jumping out of your picture. Whether you are using pencil or brush, always draw the tree branches in the direction in which the tree is growing. This will help to create a sense of growth and reality.

When you start to draw a tree, start at the base of the trunk and work upwards as though the tree were growing from your pencil or brush. Where the tree is mostly foliage, let the brush strokes follow the direction of the 'fall'

of the leaves. It is often tempting to go on a little too long with a bigger brush because you are in the swing of things but don't. When the brush gets too big for smaller branches or leaves, change to a smaller brush.

◄ Try these exercises using oil paint. Start with a turpsy wash and paint the tree from the base upwards. Painting things the way they grow makes them look more natural.

◄ For the feathery branches, load a Bristlewhite brush with a small amount of paint and drag it round and in an outward direction over the dry, already-painted branches.

◄ A common technique is to use a small brush to paint in sky colour between some of the larger branches.

► Copy these examples of trees. They will help to give you more confidence when you go outdoors to work. The top four were painted in watercolour on Bockingford watercolour paper 200 lb Not. The two oils below these were painted on primed Waterford watercolour paper 200 lb Rough. All are reproduced half the size they were painted.

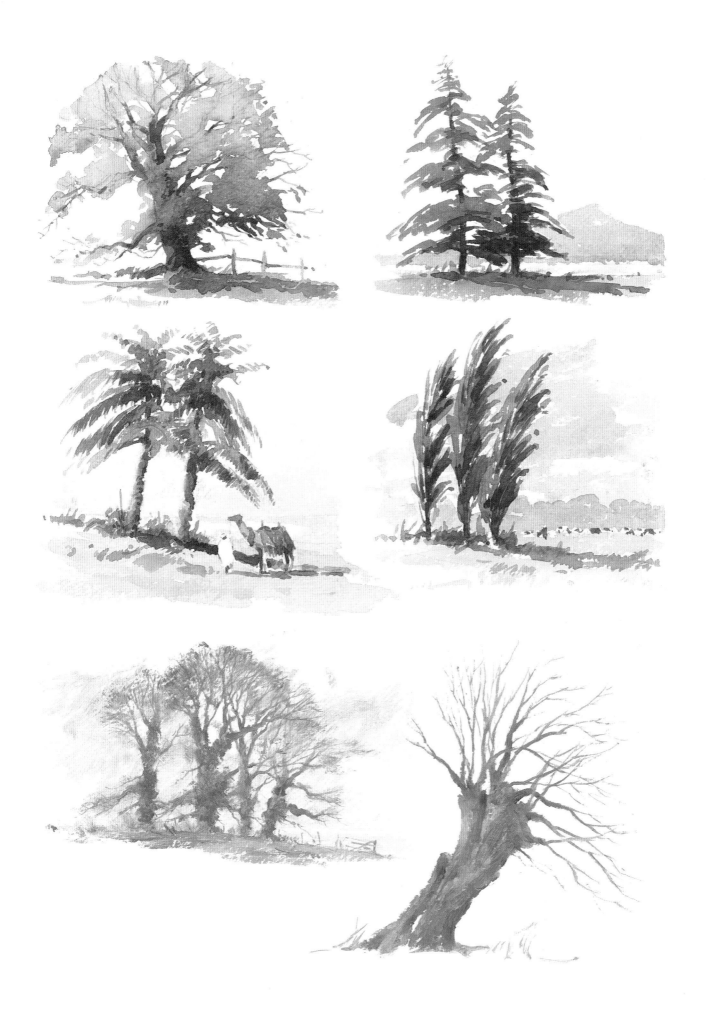

Painting Water

Water is a very exciting subject to paint. It has so many moods and, like the sky, it is always changing. I have always been fascinated with water. I am a keen angler and I have observed water in its many moods, from sunrise to sunset – misty, clear and muddy – and I still get excited about painting it.

Never overwork it

When painting water, there are certain rules that must be observed and the most important of all is that all movement lines or shapes must appear perfectly horizontal on the canvas or paper, otherwise you will find that you have created a sloping river or lake in your painting! Another important rule to remember is not to overwork the water, especially in watercolour.

Upon reflection...

Finally, painting a reflection in water will always give the illusion of water to the onlooker. The three simple paintings on the right illustrate the use of reflections.

Sometimes you will find that the reflection of the sky is all you will see in water, especially in small areas, such as puddles of water or an area of water that is completely covered by one solid reflection without any distinguishing shapes. However, if you painted 'unreflected' water it might not be convincing. When nature lets you down, use your 'artistic licence' and put a reflection in! This could be anything from a broken branch, a fence post, a clump of grass, or even an exaggerated cloud formation. Although nature is a wonderful master, there are times when an artist needs to give it a little extra help on paper or canvas.

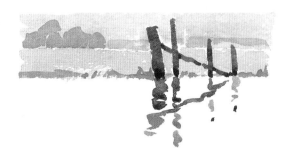

◄ By painting in simple reflections of the posts, white unpainted paper becomes water.

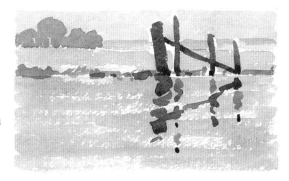

◄ Here I painted a simple wash for the water, finishing with a dry brush technique. When this was dry, I added the reflections.

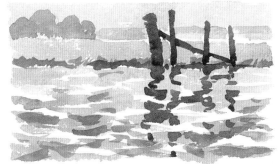

◄ More movement in the water can be achieved by working short horizontal brush strokes of varying tones. Notice that the reflections were painted in the same way. I used the same colours for the reflections as the posts.

Simplifying water on location

The three paintings shown on the opposite page are all good examples of how you can simplify your water. These were done on location where usually there isn't time to paint 'complicated' water. But even if you have lots of time, try to keep things reasonably simple.

► **From Parknasilla, Ireland**
watercolour on cartridge paper
20 x 28 cm (8 x11 in)
Of the three paintings on this page, this one is the simplest. I painted the water in one wash, changing the colour slightly as I worked down the paper.

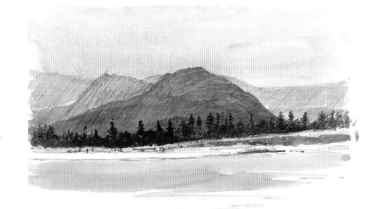

◄ **The Windmill at Hickling**
watercolour on cartridge paper
20 x 28 cm (11 x16 in)
This painting was done looking towards my house. I left the puddles of the ploughed field as unpainted white paper when I painted the field, then added colour. The reflection of the telegraph pole helps give the illusion of water.

▼ **The Grand Canal, Venice**
watercolour on cartridge paper
20 x 28 cm (8 x 11 in)
I achieved the choppy water of the canal by working the first wash in short horizontal brush strokes, leaving white paper showing in places. When this was dry, I painted small brush strokes, then larger ones towards the base of the paper to show perspective. I didn't put in reflections – there weren't any and I decided none were needed!

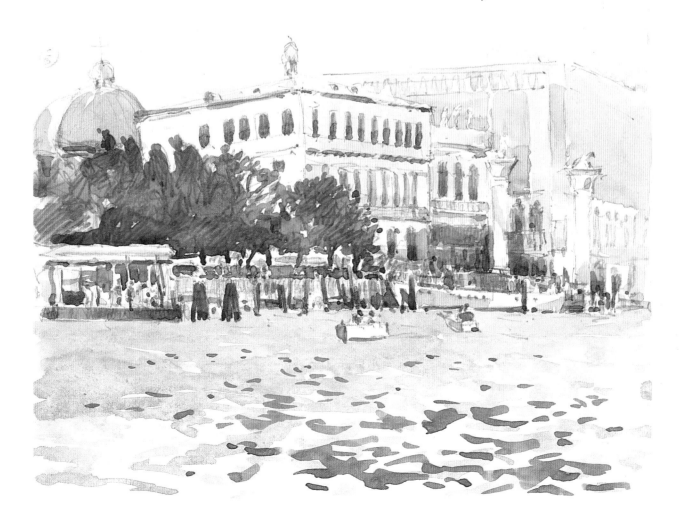

The colour of water

The biggest worry for most students when painting water is its colour. As with trees, the secret is observation and then simplification of the shapes and tones. The colour of water is dependent on its surroundings; the objects it reflects – sky, trees or buildings – will show their shape and colour in it and so determine the colour of the water. Light colours are slightly darker when reflected than the real thing, while darker colours are slightly lighter.

As with the sky and trees, start by sketching in pencil. Find some still water with good reflections, sit down and look at the water and its surroundings, half-close your eyes and see the shapes and tones of the reflections. When you're confident that you've simplified the shapes in your mind, do a sketch in 3B pencil.

Movement of water

Painting moving water with reflections is a little more difficult. Like the sky, it won't keep still. Observe the water and its surroundings and try to look in one place, i.e. don't let the flow of the water take your eyes with it. If you can do this, you will then be able to make out the shapes and colours of the reflections.

Although water may move, reflections from the land stay still. The water's movement breaks up the shapes of the reflections, giving them strange shapes, but with half-closed eyes you should be able to sort out the major shapes and forms. Don't fall into the trap of painting horizontal lines all over your water. This can make it look artificial and contrived. Keep horizontal lines for definite effects of water movement or reflected light.

▲ First stage

▼ Finished stage

Painting still water

This oil painting on a Daler board measures 15 x 23 cm (6 x 9 in). I pre-painted the surface with an acrylic wash of Raw Sienna and Crimson Alizarin.

First stage

Draw the picture with your No. 6 sable brush and paint in the tones with a turpsy wash of Cobalt Blue and Crimson Alizarin. Notice how the acrylic ground colour shows through, helping to give the atmosphere. Now paint in the sky using Titanium White and Cadmium Yellow with your No. 4 Bristlewhite brush.

Finished stage

Paint in the distant trees with Titanium White, Cobalt Blue and Crimson Alizarin. Add Yellow Ochre to the mix and paint the dark hedge and its reflection. Paint over the trees, adding their reflections. Work the green bank using Cadmium Green, Cobalt Blue, Crimson Alizarin and Titanium White. Paint in the river with a Titanium White and Cadmium Yellow mix. Add a little Cobalt Blue and Crimson Alizarin to darken the tree reflection. Finally, paint in the highlights on the water.

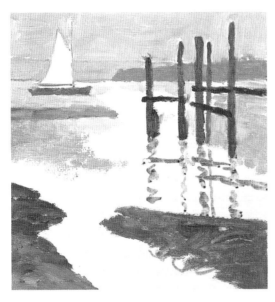

▲ First stage ▼ Second stage

Painting moving water

I painted this exercise on oil sketching paper, coarse grain measuring 17 x 17 cm (7 x 7 in).

First stage

With your No. 6 sable brush and a turpsy mix of Cobalt Blue and Crimson Alizarin, paint the important features. Leave the water unpainted.

Second stage

With a mix of Titanium White, Cobalt Blue and Crimson Alizarin and your D48 No. 4 brush, paint the sky. Add Yellow Ochre and paint the distant hills. Add more Cobalt Blue and paint the headland. Use the sky colours to paint in the sea. With the same colours, but less Titanium White, paint the posts and yacht. Use more Yellow Ochre to paint in the mud foreground.

Finished stage

Paint in more sea and then using Titanium White and Cadmium Yellow, add the highlights to the water. Now paint over the reflections of the posts using your D48 No. 2 brush. Add highlights to the mud and use a little Cadmium Green with your colours. Finally, decide if you want a white sail or red one. I decided on red and used Cadmium Red and Crimson Alizarin. I used my No. 2 Bristlewhite brush for any small work.

▼ Finished stage

Never overwork water. In watercolour, paper can be left unpainted to represent water. With oil, only use thick paint for movement or for highlighting water.

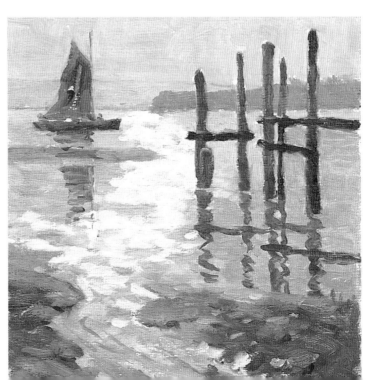

Painting Foreground

The 'ground' in a landscape is very important as it usually represents the nearest part of the landscape. This means that, in most cases, it will have to show the most detail. The detail can be slight, depending on the subject or the style of painting, but often it will have to represent a true and detailed account of itself. This brings me back to observation! By observing, you will become your own teacher and, with practice, paint happily for the rest of your life!

Meanwhile, let's get back to your sketchbook and 2B pencil. Go out into the countryside or in your own garden and sit, look and observe. This is where the information sketch is really necessary. You must draw to learn what happens to things – how a fence goes into the ground; how a cart track is formed; how grass grows; how wild flowers grow, and so on. If your drawing isn't that good at the moment, then try painting directly what you see, to create the same effect.

▲ First stage

Using the dry brush technique

This is a very exciting way to paint a foreground. I worked this exercise on Bockingford watercolour paper 200 lb Rough, measuring 12.5 x 20 cm (5 x 8 in).

First stage

Using your No. 10 sable brush and a mix of Crimson Alizarin, Yellow Ochre, French Ultramarine and Hooker's Green Dark, drag your brush over the paper in a dry brush technique, changing the colour as you go. You will be left with a foreground of happy accidents, but under control!

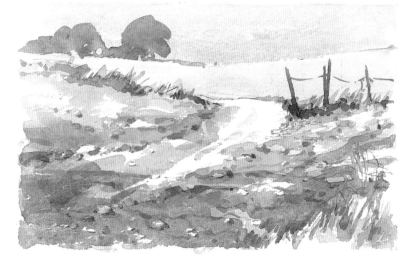

▼ Finished stage

Finished stage

Look for shapes left by the first wash, refine them if you want, and add shadows to them. Add more colour in places and make more shapes. This process can go on as long as you are not overworking the foreground. Finally, put a shadow over the immediate foreground – this could come from any object out of the picture. If you were outside painting, your original wash would take note of the real live foreground you were copying. Here, the sun is on the left, therefore the shadows are cast on the right of objects.

Underpainting with acrylics

When painting with oil, try underpainting with acrylic colours first. The advantage is that they dry quickly and the oil paint will not pull them up when you paint. The acrylic colours I used were Raw Sienna, Raw Umber, Bright Green, and Crimson. The surface was canvas panel, 15 x 23 cm (6 x 9 in).

First stage

Draw the main flowers in simply with a No. 6 sable brush. With a mix of Raw Umber and Titanium White and a No. 4 Bristlewhite brush, paint the left side of the background, changing to Cobalt Blue and Titanium White as you work to the right. Paint in the poppies with Cadmium Red and a little Cadmium Yellow.

Finished stage

Work more colour into the poppies, using Cadmium Red, Cadmium Yellow, Crimson Alizarin and a touch of Titanium White. Use a No. 2 Bristlewhite brush. Then paint in the green background around them using Cadmium Green, Cadmium Yellow and a little Titanium White. Paint in the dark leaves and then the small white and mauve flowers. All this can be done with a No. 2 Bristlewhite brush or a No. 6 sable. As I have said earlier, it is impossible to copy my paintings exactly, even I couldn't do that. But have a go at this one – you will enjoy doing it.

▲ First stage

▲ Finished stage

Remember, cool colours (i.e. blues) recede in a painting, while warm colours (i.e. reds) come forward.

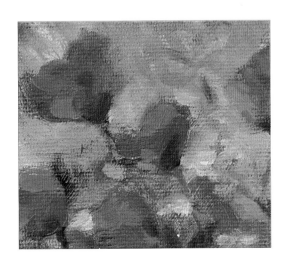

◀ Close-up detail, reproduced actual size.

Trees in the foreground

First stage

I used Bockingford paper 200 lb Not for this watercolour exercise. It is painted with much more freedom than *Misty Morning*, opposite. Start by painting the sky with your No. 10 sable brush using a mix of French Ultramarine and Crimson Alizarin. While it is wet, add Cadmium Yellow Pale and, as you work down, add more Crimson Alizarin. Now let this dry.

Second stage

Use your No. 6 sable brush and paint in the large tree trunk. For this, mix Hooker's Green Dark, Crimson Alizarin and a little Yellow Ochre. Start with a watery mix on the left of the trunk for sunlight. Then with Yellow Ochre and Crimson Alizarin paint in the tree to the right of it. Finally, with the same colours as the large tree, with a little more Yellow Ochre, paint in the tree on the far right.

Third stage

Paint in the hedge and the ground with watery paint, but paint it using free upward, curving brush strokes. Let these 'hit-and-miss' as you did with the foreground on page 38. When it is dry, suggest some leaves and bracken. Use Yellow Ochre and Crimson Alizarin for the bracken colour. Keep your brush strokes loose and free – don't try to get individual detail.

Finished stage

For this stage, use your No. 6 sable and your rigger brush. Paint in the shadow side of the large tree and put shadows on the smaller trees. Now add more branches. Then suggest small branches, leaves, bracken and brambles in the hedgerow with your rigger brush. Finally, use your No. 6 sable brush and paint in the cast shadow on the ground. Observe the way trees come out of the ground. The trunk is usually hidden with other growth, except for trees in park-like conditions.

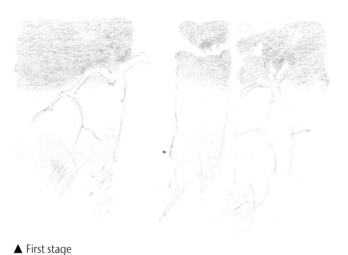

▲ First stage

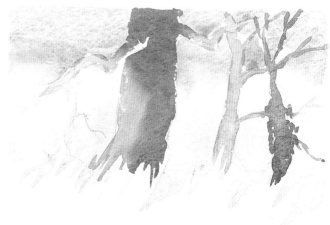

▲ Second stage

▼ Third stage

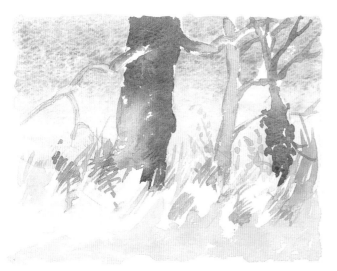

▼ Finished stage

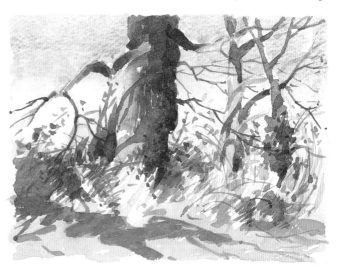

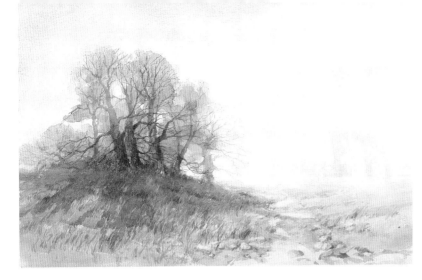

◀ **Misty Morning**
Bockingford paper
200 lb Not
38 x 50 cm (15 x 20 in)
Notice how the foreground is in keeping with the mood of the painting. It has been done softly, using muted colours. Just because you can see detail to put into the foreground of a painting, don't overdo it. In fact, in this picture, the sun and trees are the centre of interest, not the foreground.

▼ Close-up detail of the foreground.

Painting close-up detail

A word of warning about painting close-up detail. If you are painting a tree in leaf on a canvas, say 25 x 20 cm (10 x 8 in), the leaves, to be in scale, would have to be smaller than a full stop on this page. You would paint that tree by defining groups of leaves as detail, not each single leaf. Scale is very important.

When you are out sketching, always make sure you put something in your picture that denotes scale. If there is nothing definite around, then sketch your stool, your hat, or a dog in the picture. This only needs to be done simply, but it will give scale to your sketch and I can't stress enough how important that is.

Things that grow

When you are working on the foreground and you are painting grass, bracken and other things that grow, work your brush strokes in the same direction as their growth and movement. Every brush stroke conveys a story, and you should take advantage of this, especially in close-up work.

Snow can be tremendous fun to paint but it can present problems for sketching and working outdoors. However, if you can get the car out on the road, you can always work from its relative comfort or, alternatively, at home from a window. The stillness and silence of a snowy landscape can be unbelievable. The clear rivers of spring and summer turn to brown, and trees stand out in sharp silhouette.

Capturing snow

A pencil sketch of a snow landscape can be extremely rewarding, with white paper showing through to suggest snow and with areas of dark pencil tone to suggest trees and hedgerows.

Beware when you are painting snow with oil paint – in general, don't use white paint for any of it. Snow is only white in its purest, just-fallen form and, even then, it reflects light and colour from its surroundings. Even the whitest snow should have some colour. Add a little blue to cool white oil paint or a little red or yellow to warm it up.

Never be afraid to make snow dark in shadow areas. It can be as dark, in comparison to its surroundings, as a shadow in a non-snow landscape. Paint snow in a low key: if you take your darkest shadow as number ten and your brightest snow as number one, with a natural gradation of tone in between, you should paint your snow in the range from eight to three. This will leave enough reserve up your sleeve to add darker shadows and brighter highlights.

Pencil Sketching Outdoors

I have said quite a lot so far about sketching and in particular sketching in pencil. You will be familiar with my definitions of sketches from an earlier section. On these pages I have shown three: one information sketch and two enjoyment sketches.

Basic rules

Some very basic rules of common sense apply when you work outside. If you go out sketching or painting, take enough clothing. It can always be taken off, but if you haven't got it you can't put it on – and, if you are not reasonably comfortable or warm, you will not produce your best work. Keep your sketchbook in a polythene bag. I have always done this since I dropped mine in a puddle! You will need two pencils, a knife to sharpen them with (incidentally, always sharpen them before you go out), a putty eraser and your sketchbook. I suggest you use a 2B and a 3B pencil for sketching. The 3B is softer and ideal for shading areas quickly. However, I find I use a 2B pencil for most of my sketching.

Don't go round every corner

When you see a spot for sketching, don't be tempted to walk around the next corner to see if the view is better. When you get there, you could be tempted to go around the next corner, and so on. You will end up coming back to the same spot – an hour later – or carrying on around the next corner and ending up sketching nothing! I've fallen into this trap on quite a few occasions and it is very frustrating, especially if you are with your family or sketching friends and they are waiting for you to settle down! So, if something inspires you – sketch it. If you have enough time, you can go around the next corner and do another sketch.

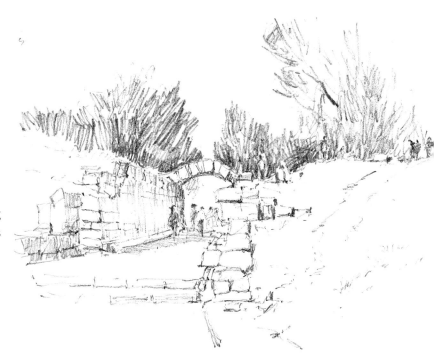

▲ When we were in Greece, I just had to sketch the entrance to the stadium in Olympia (drawn from inside the stadium). This was where the first Olympic Games were held over a millennium ago. I really enjoyed doing this sketch and felt that, for a few moments, I had been a part of history. I did it in my A4 cartridge sketchbook with a 2B pencil. Note how the figures give scale.

◄ I did this information sketch when I was in Japan. I sat down to work, using a 2B pencil and my A4 cartridge sketchbook. When you're sitting down, you have complete control of your pencil, as your hand can rest on the pad which in turn rests on your knees. I took a photograph of the scene for colour reference and any detail that I might need, in case I wanted to do a painting from this sketch at home.

Making a picture finder

It can be very difficult to look at a scene and know exactly where to start and finish your sketch or painting. To help yourself, cut a mask out of paper or thin card with an opening of about 10 x 8 cm (4 x 3 in), or make the mask the same proportion as your sketchbook so your picture will fit nicely on your paper.

Hold the mask up at arm's length, close one eye and move your arm backwards and forwards and from side to side until the scene is sitting happily in the opening. Then make a mental note of the position of your arm, and key points where the scene hits the inside edge of your mask. You will then have the picture designed in front of you (see my example, above right). Draw the positions of the main features and then relax your arm, put the mask away and draw your sketch.

If you forget your mask when you are out, make a square with your hands and look through them.

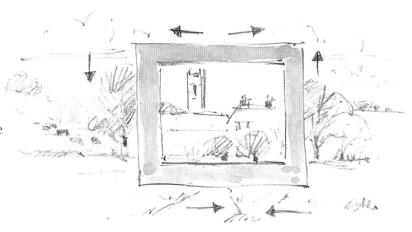

▲ Cut out a mask from card to help you decide what to draw.

► I did this sketch while waiting for the TV crew to pack up when we were filming in Seville. I used my A4 sketchbook and 2B pencil. I was stood on the side of the road, hence the freedom of the pencil lines. It took about 6 minutes of hard concentration, but the pleasure it gave me will last for ever. This was a true enjoyment sketch.

◄ Practise shading on any piece of scrap paper. You must gain complete control of your pencil – it will make your sketches come to life. This tonal shading was done with a 2B pencil. The pencil on the left is the correct way to sharpen your pencil. You can see the point when working and you can get some broad flat strokes for shading. Never sharpen your pencil like the one on the right!

43

Hickling Church

I have painted my local church on many occasions. I did the sketch, below left, one early spring afternoon. My inspiration was the sun coming out after a heavy shower, bathing the whole scene in light and shadows. However, the wonderful thing about painting from a pencil sketch at home is that you can create any type of weather conditions from your imagination and experience.

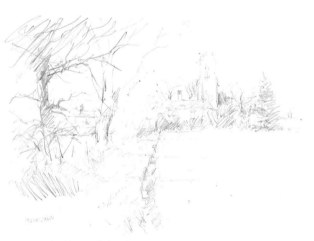

▲ *2B pencil sketch on cartridge paper*
20 x 28 cm (8 x 11 in)

First stage

Using my 2B pencil, I started by positioning and drawing the church tower, then drew a line underneath the tower for the end of the two fields. The path and the two large trees were drawn next, and finally the area around the church and the white cottage on the left. Don't try to draw in detail because this can restrict the freedom in your brush strokes as you try to copy your pencil lines. I painted the sky with my No. 10 sable brush, starting at the top with a wash of French Ultramarine and Crimson Alizarin. I then let some Yellow Ochre run into the wet paint, with plenty of

Colours

French Ultramarine

Crimson Alizarin

Yellow Ochre

Cadmium Red

Hooker's Green Dark

Cadmium Yellow Pale

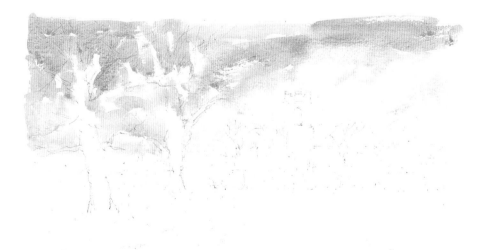

▶ First stage

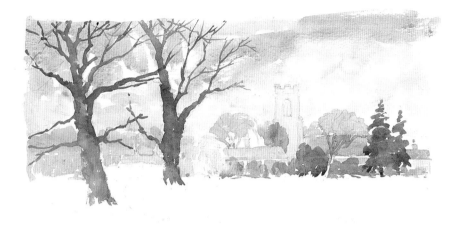

water to give the illusion of sunlit clouds. Notice the small areas of unpainted paper – these help to give light and life to the sky.

Second stage

When the sky was dry, I painted the tower using the Yellow Ochre and my No. 10 sable brush. Then I added some Cadmium Red and painted in the red roofs. Next, adding French Ultramarine, I painted the church roof. I painted the distant trees, working from left to right, with a mix of French Ultramarine, Crimson Alizarin and Yellow Ochre. I added more Yellow Ochre and Hooker's Green Dark to this to paint the bushes and trees in front of the church. Don't worry if some areas mix and blend together because they are wet. This can help to give a more natural look. I painted the two large trees with my No. 6 sable brush and rigger (for the small branches). By now you should be happy with painting trees – if you have been practising! Don't overwork them at this stage.

Third stage

Now, with a mix of Cadmium Yellow Pale and Hooker's Green Dark and my No. 10 sable brush, I painted in the field on the left of the picture. I then mixed French Ultramarine and Crimson Alizarin together

to paint in the puddles. While the puddles were still wet, I mixed a wash of Yellow Ochre and Crimson Alizarin, adding some of the colours already in my palette (greens and blues), and painted the path and the ploughed field. I let the field colour mix with the wet puddle colour in places. It was very important to paint the brush strokes of the path and field in perspective. The unpainted white paper that was 'accidentally' left also helps to make the field look flat.

▼ Third stage

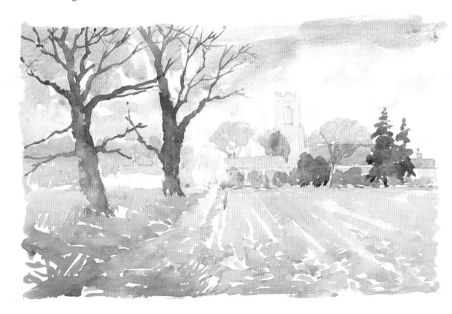

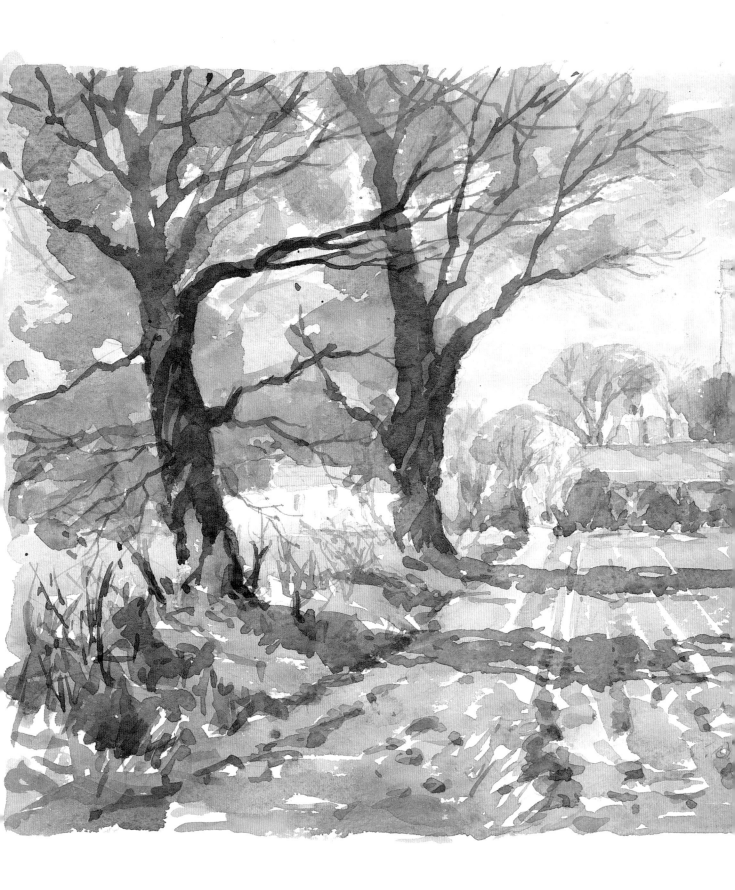

Finished stage

With my No.10 sable brush I put the 'feathery' branches on the two main trees. I used French Ultramarine, Crimson Alizarin and Yellow Ochre. I started at the top and worked down, leaving some light areas on the trunks to represent sunlight – this is important, and don't paint over the white cottage! While this was drying I put in some detail on the church tower, buildings and distant trees with my No. 6 sable and rigger brushes. I added some dark blue to the left of the white cottage to give distance behind the cottage and to define its shape. I then added darker tones and some 'free' detail to the hedge on the left under the trees, with my No. 6 sable and rigger brushes. Then, with a watery mix of French Ultramarine and Crimson Alizarin, I painted in the shadows cast by the two large trees. Notice how they follow the contours of the ground. Finally, I put some shadows on the stones and lumps of earth on the path and field.

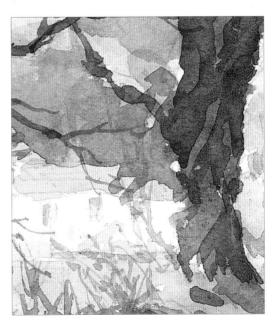

▲ Detail from finished stage, reproduced actual size.

◄ **Hickling Church**
watercolour on Bockingford watercolour paper 200 lb Not
25 x 40 cm (10 x 16 in)

Sydney Harbour Bridge

When I was in Australia and visiting Sydney, I couldn't resist sketching the Sydney Harbour Bridge in watercolour on cartridge paper from two or three vantage points. For this demonstration, I have worked on cartridge paper in the same way that I do outdoors but, because of the 'perfect' working conditions in my studio, it is a little neater!

First stage

With a painting like this, you have to be confident about your drawing skills, as the most important element of the painting is the bridge. But don't let this put you off – have a go and enjoy it. I drew the water line in with my 2B pencil first and then positioned the bridge, the background buildings, the boat and, finally, the landing stage. I painted the sky with my No. 10 sable brush with a wash of French Ultramarine and Crimson Alizarin. Notice how I left areas of unpainted paper to represent drifting clouds. I used horizontal brush strokes for the sky, and added more water to make the sky at the horizon lighter.

Second stage

I painted in the distant buildings with my No. 6 sable brush and used a varying mix of French Ultramarine, Crimson Alizarin, Yellow Ochre and a touch of Hooker's Green Dark to suggest trees to the left end of the buildings. I purposely left white areas of unpainted paper to represent sunlight on the buildings and triangle shapes to represent yacht sails. I used Yellow Ochre with a touch of Crimson

Colours

French Ultramarine

Crimson Alizarin

Yellow Ochre

Hooker's Green Dark

Cadmium Yellow Pale

Coeruleum

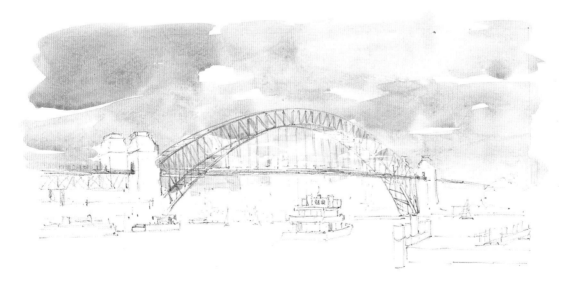

▲ First stage

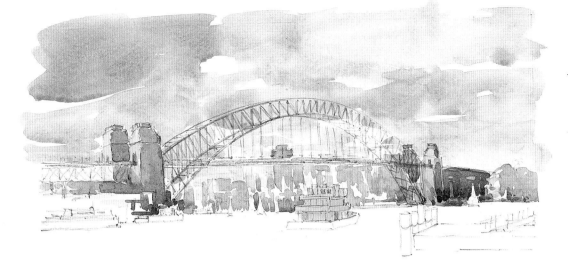

Alizarin to paint the towers of the bridge. When these were dry, I painted on the shadows. Finally, with a Yellow Ochre and a touch of Cadmium Yellow Pale – still using my No. 6 sable brush – I put a wash on the boat.

Finished stage

With the same colours I used for the distant buildings, but darker, I painted shadows on them, being careful to go round the yacht sails. At the same time, I suggested the two boats to the left of the bridge. I painted the water next with my No. 10 sable brush with a wash of Coeruleum and Cadmium Yellow Pale, changing to French Ultramarine and Crimson Alizarin halfway down. Notice how I left white, unpainted paper to represent reflected light. I then painted in the landing stage. I put some darker areas on the shadow side of the boat and painted the reflections and some small brush strokes in the foreground water to give movement. Finally, I carefully went over some of the pencil drawing on the bridge with dark colour using my No. 6 sable brush.

▼ **Sydney Harbour Bridge**
watercolour on cartridge paper
20 x 28 cm (8 x 11 in)

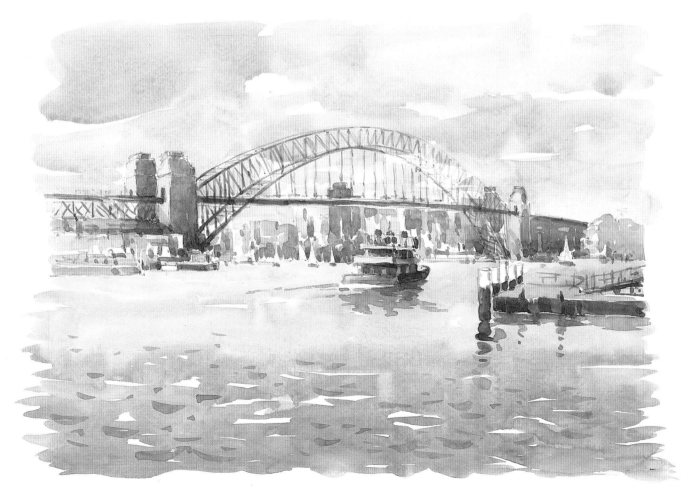

Tuscan Landscape

*I have always loved the colours you find in an Italian landscape.
In this particular scene, the road runs upwards through
sun-baked fields, leading the eye up to the town on the top of
the distant hill. When you are out painting, it's amazing how
many times nature comes up with the best composition –
without the artist having to move mountains!*

Colours

Cobalt
Blue

Crimson
Alizarin

Yellow
Ochre

Viridian

Cadmium
Green

Titanium
White

First stage ▶

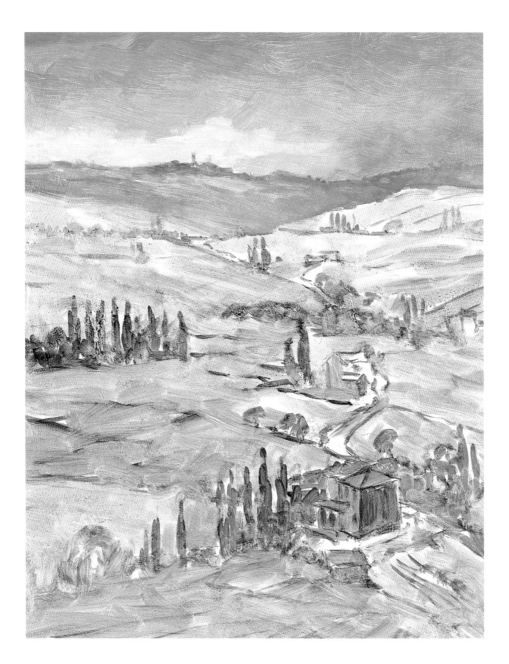

First stage

If I had been working on this painting outdoors, I would have probably gone straight in with the paint and not used pencil. But because I was working indoors so that the stages could be photographed, I had more time and I drew in the important features first with my 2B pencil. Then I painted the picture with a turpsy wash of Cobalt Blue and Crimson Alizarin using my No. 6 sable brush. Notice how freely this was done. Remember, when you are using oil paint, adjustments and corrections can be done at most times during a painting.

Second stage

I painted in the sky with my No. 8 Bristlewhite brush and a mix of Titanium White, Cobalt Blue and Crimson Alizarin. I added more Titanium White and Yellow Ochre behind the distant town. I continued down into the distant hills, adding more Cobalt Blue and working my brush strokes diagonally to follow the slope of the hills. A turpsy wash of Yellow Ochre, Crimson Alizarin and a little Cadmium Green over the rest of the landscape gave it an underpainting of warm earth colours and scrubbing the brush harder over the blue drawing lines lifted them, making them less prominent.

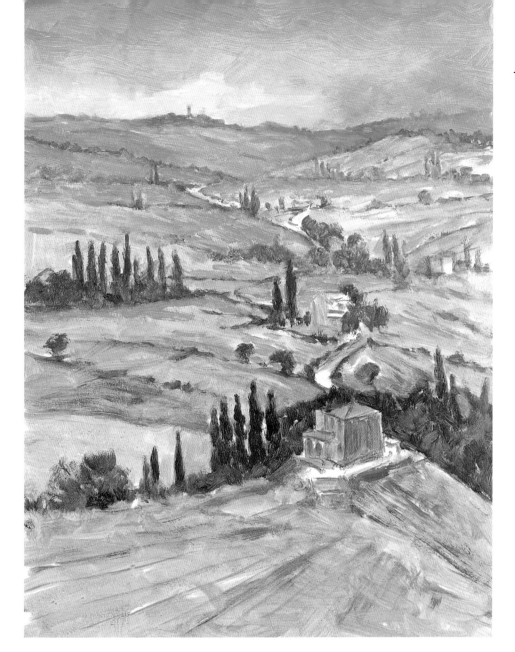

◀ Third stage

Third stage

I mixed Cobalt Blue, Crimson Alizarin, Viridian, a little Cadmium Green and a little Titanium White and, using my No. 6 sable brush and No. 2 Bristlewhite brush, started at the top and painted the distant trees and hedges and worked down the canvas, getting darker and making the colour warmer by adding more Crimson Alizarin and Yellow Ochre nearer the bottom of the picture. Then, with the same colours as I had used to apply the turpsy wash over the field in the second stage, but this time adding Titanium White, I painted over the fields once more, but now with thicker paint and using my No. 2 Bristlewhite brush.

Finished stage

I continued down the canvas, adding paint to the fields and making the colours stronger and warmer. I then painted in the shadows on them, letting the brush strokes follow the contour of the fields. Next, I put more work into the houses and the field on the right beneath the house. I painted over the fields in the foreground to give them more life using thick paint and my No. 4 Bristlewhite brush. I then decided to make the foreground shadow a little more mauve and painted over the top of the original one. When you get to this stage, leave the painting for a while, then come back with a fresh eye. You will then see if you need to 'add or subtract' to finish your painting.

▶ **Tuscan Landscape**
oil on primed MDF
40 x 30 cm (16 x 12 in)

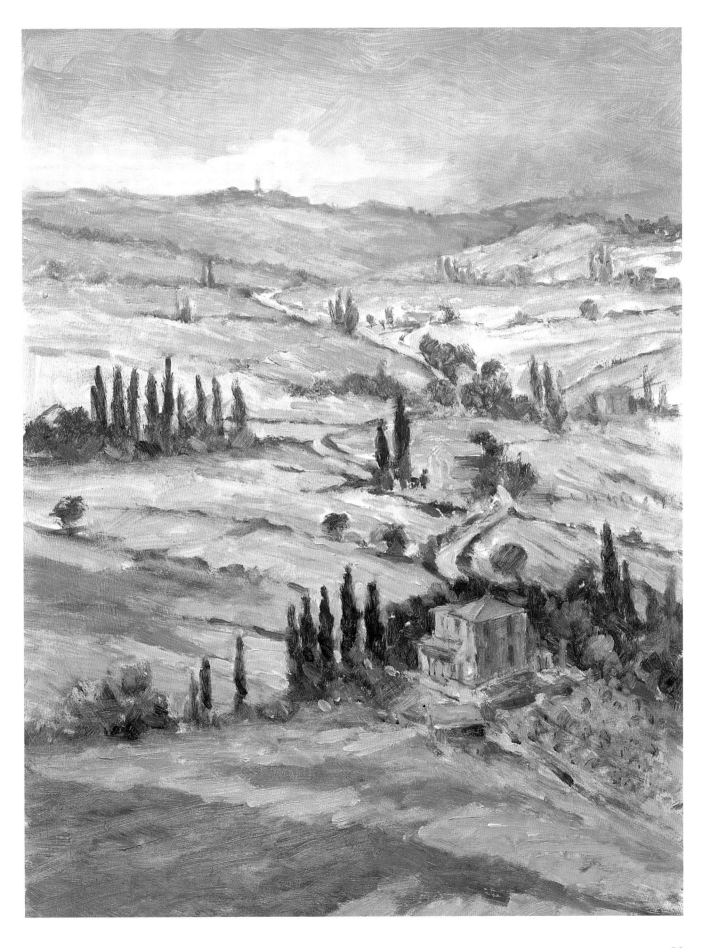

Camels in Egypt

I was in Egypt filming for a television series and couldn't leave without sketching and photographing some camels. It was also important to experience the heat and see the heat haze in the distance. Notice how the leading camel rider is a tourist with her small backpack, sitting upright and holding on. I had a ride on one, and take it from me, you do have to hold on – very tightly!

First stage ▶

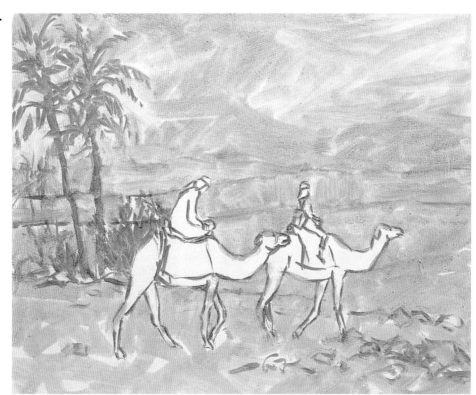

Colours

Cobalt Blue

Crimson Alizarin

Yellow Ochre

Cadmium Green

Cadmium Red

Titanium White

First stage

I drew the scene with pencil first, as I did in my Tuscany painting on page 50. Then I drew in the painting over the pencil with my No. 6 sable brush and a turpsy mix of Cobalt Blue and Crimson Alizarin. Next, with a turpsy mix of Yellow Ochre and Crimson Alizarin, I painted over the whole background with my No. 8 Bristlewhite brush to achieve a warm underpainting.

Second stage

I used my No. 8 Bristlewhite brush with a mix of Titanium White, Cobalt Blue and Crimson Alizarin to paint the sky. I worked the paint thinly to allow the underpainting to show through. I worked the distant sand dunes darker with a little thicker paint. Then I painted in the palm trees and the small bush with my No. 4 Bristlewhite brush and a mix of Cobalt Blue, Crimson Alizarin, Cadmium

54

Green and Yellow Ochre. Notice how freely I did this. Finally. with a turpsy wash of Yellow Ochre, Crimson Alizarin and a little Cobalt Blue, I painted in the leading camel.

Finished stage

I worked with thicker paint on both camels using my Dalon D77 No. 6 brush, which gave more positive brush strokes than my sable brush. I worked the riders, their saddle blankets and trimmings next with the same brush. I then put in the shadows cast by the camels and the rocks and stones. I then painted over the sand again with thicker paint, using my No. 2 and No. 4 Bristlewhite brushes. I also thinned down the camels' legs, where they had become too thick. Finally, I put some more paint on the rocks and put in the riders' reins with my rigger brush.

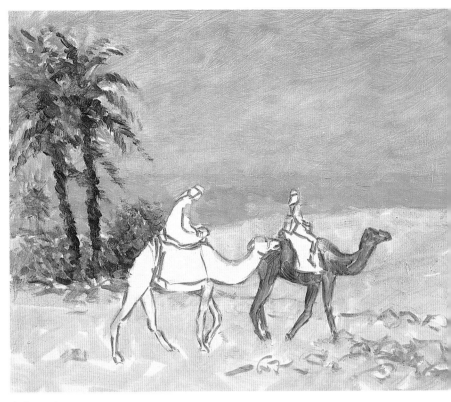

▲ Second stage

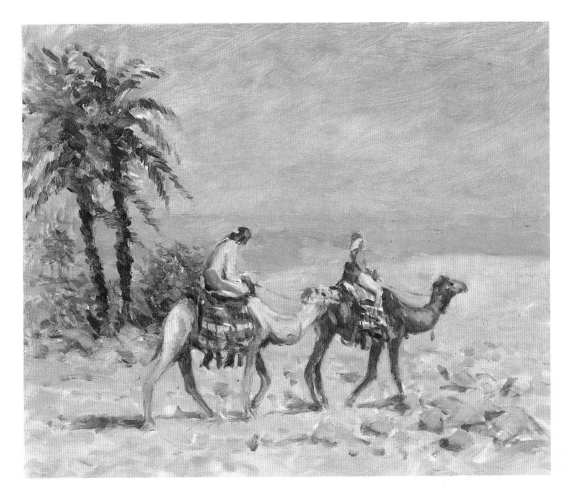

◄ **Camels in Egypt**
oil on primed MDF
25 x 30 cm (10 x 12 in)

Dedham Lock

Dedham is a favourite place for me. The landscape artist John Constable lived and painted in this area. Although he died over two hundred years ago, his work was my main inspiration at art school. In this demonstration, the sun has come out on an early spring day. It's the type of day that gets you excited and makes you feel spring is really here – until, the next day, when clouds cover the sky and it's cold and wintery again!

First stage

To begin with, I drew the scene with my 2B pencil. As with the painting of Hickling Church on page 44, don't try to put too much detail in with your pencil, but make sure the house and lock gates look correct. Position the trees, but leave the small branches undrawn; they can be put in with a brush. I painted the sky with my No. 10 sable brush as usual, using French Ultramarine and Crimson Alizarin, and adding plenty of clouds (Yellow Ochre and Crimson Alizarin) across the sky. This helped to silhouette the trees and show their shape. Don't be afraid of hard edges on clouds because this can often help a watercolour.

Second stage

I painted the background trees when the sky was dry. I used my No. 10 sable brush with a varied mix of French Ultramarine, Crimson Alizarin and Yellow Ochre, with a touch of Cadmium Yellow Pale. I then painted in the roof and chimney stacks using Cadmium Red and a touch of Cadmium Yellow Pale. When the background trees were dry, I painted the main trees with my No. 6 sable and rigger brush. Notice how I used a strong green on

Colours

Yellow Ochre

Crimson Alizarin

French Ultramarine

Cadmium Yellow Pale

Cadmium Red

Hooker's Green Dark

▼ First stage

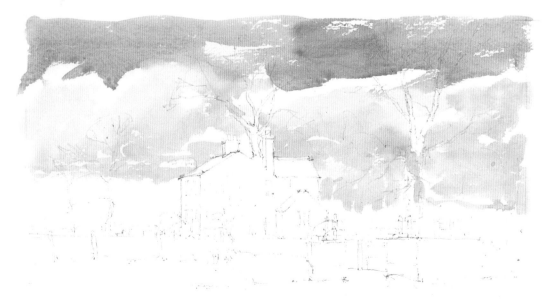

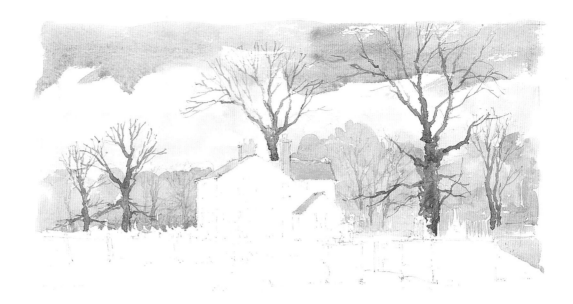

the large tree on the right to show sunlight. While I had green on the brush, I painted the little area of grass bank on the right side of the lock.

Third stage

Next, I painted the walls of the house with Cadmium Yellow Pale and a touch of Crimson Alizarin using my No. 6 sable brush. Then I did the green lawns with Cadmium Yellow Pale and a little Hooker's Green Dark, working down into the river bank. I painted the lock with Yellow Ochre and a touch of Crimson Alizarin. I also painted the green moss on the bottom of the walls. Next, with a wash of French Ultramarine, Crimson Alizarin and Yellow Ochre, I painted the shadow sides of the house. Then, making the same colour darker, I painted the shadow sides on the lock. I then darkened the river bank. Finally, still with my No. 6 sable brush, I painted in the windows and shadows on the chimney stacks and roof, and painted the small bush on the bank with my rigger brush.

◀ Third stage

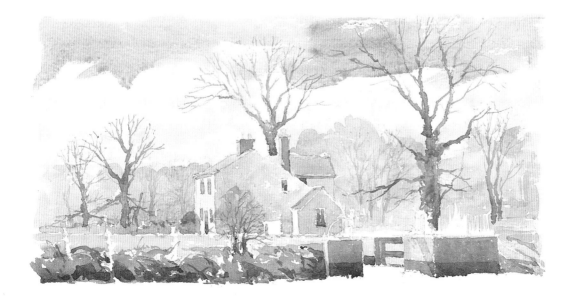

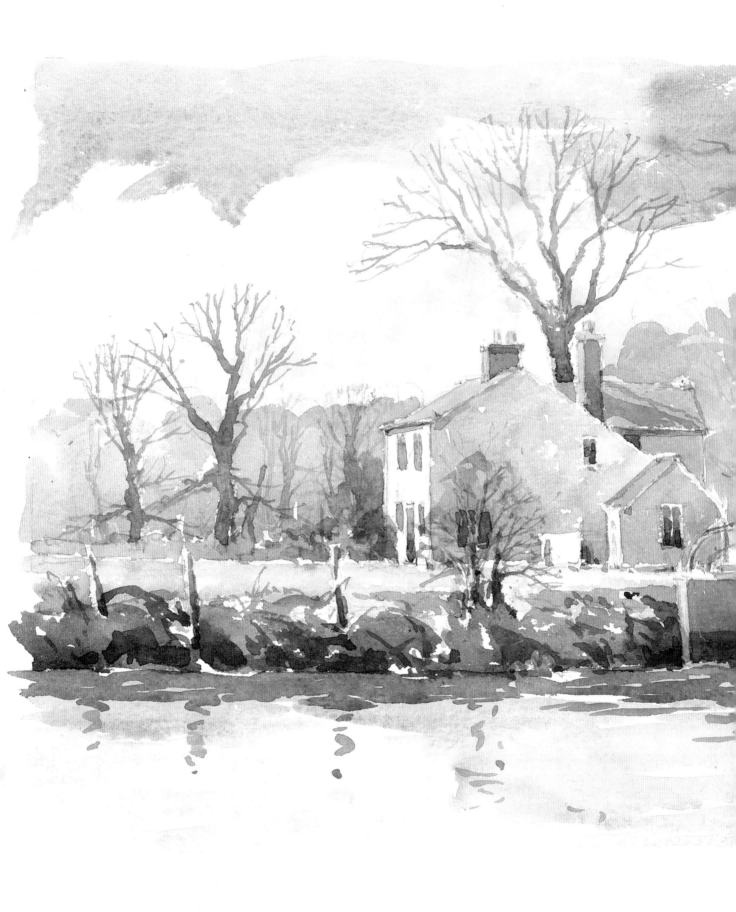

Finished stage

Now I painted the water with my No.10 sable brush, starting with a wash of French Ultramarine and a little Crimson Alizarin, adding Yellow Ochre and water as I worked to the bottom. As usual, this was done with horizontal brush strokes, leaving some unpainted areas for movement. I painted in the posts on the bank and the railings over the lock with my No. 6 sable brush, and suggested the railings on the right of the lock. Using the same brush, I mixed a wash with French Ultramarine, Crimson Alizarin and Yellow Ochre and painted in the reflections. Notice how simple they are – if you keep them simple, they will look more convincing.

I then added some accents of dark paint where I felt it would help the painting. Notice how many accidental small 'chips' of white, unpainted paper there are over the whole of the painting. This helps to give light and energy to the painting.

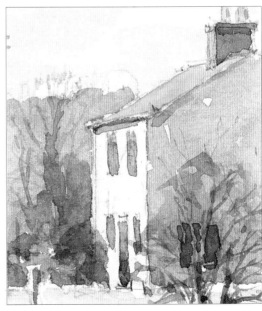

▲ Detail from finished stage, reproduced actual size.

◀ **Dedham Lock**
watercolour on Bockingford
watercolour paper 200 lb Not
23 x 35 cm (9 x 14 in)

Painting from a Photograph

For this demonstration, I used a photograph of Venice taken on a painting holiday. It is a great one to work from, especially in watercolour. When you have done this, work from some of your own photographs – practise in the winter when you can't work outside!

L et me say first of all that painting from a photograph is not a short cut to learning to draw or paint. A photograph is only an aid to painting, although it can be a very good one. If you accept this, you can use photographs to work from without feeling guilty, as many students do.

After all, put yourself in the position of the Old Masters. They couldn't paint at night because they had no electricity. Yet I am sure that, if electricity had been available to them, they wouldn't have shunned science – they would have turned on the light and worked at night. Similarly, I am sure that, if the camera had been invented then, they would have taken photographs to use for reference alongside their sketches when working in the studio. So let the camera become just another tool, along with your sketchbook, modern nylon brushes, learn-to-paint videos, books, and so on.

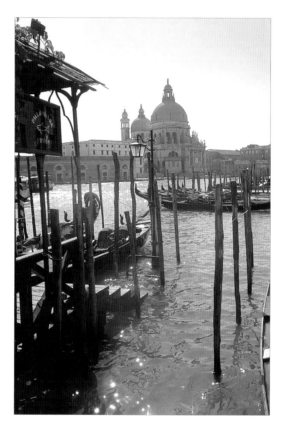

Colours

French Ultramarine

Crimson Alizarin

Yellow Ochre

Coeruleum

Cadmium Yellow Pale

Hooker's Green Dark

Do a pencil sketch first

Photography has its part to play, but take note – a photograph always flattens the middle to far distance, making it look smaller and insignificant. When we look at the same view, our eyes can unconsciously enlarge the middle distance and we then see it in isolation; it fills our vision. When you work from a photograph, you should keep this in mind. The best way to work is to draw a pencil sketch of a scene, then take a photograph. You will see the difference between your eye's image and that of the camera, and that experience and knowledge will help you. Most important of all, don't copy a photograph slavishly. You must simply use it as a guide to painting your individual masterpiece, in your own style.

One last important point – you must try wherever possible to take your own photographs to copy from. This means you have experienced the real scene.

First stage

I drew the scene with 2B pencil. To begin with, look at the photograph carefully and compare it with my finished painting on page 64. You can see that I have left out all the detail in the buildings at the back, helping to keep them in the background. I also moved the posts with the lamp on so they didn't cover the end of the first gondola, and lowered the post under the lamp to make the lamp more important. I

moved some of the posts, to make the painting read better, and exaggerated the warm light on them to create the feeling of late afternoon sunlight. I couldn't see from the photograph what was happening on the gondola on the far left, so I made it simple, which actually helped the painting. I painted the sky down to and into some of the background buildings with a wash of French Ultramarine and Crimson Alizarin, then added Yellow Ochre for the rest of the sky.

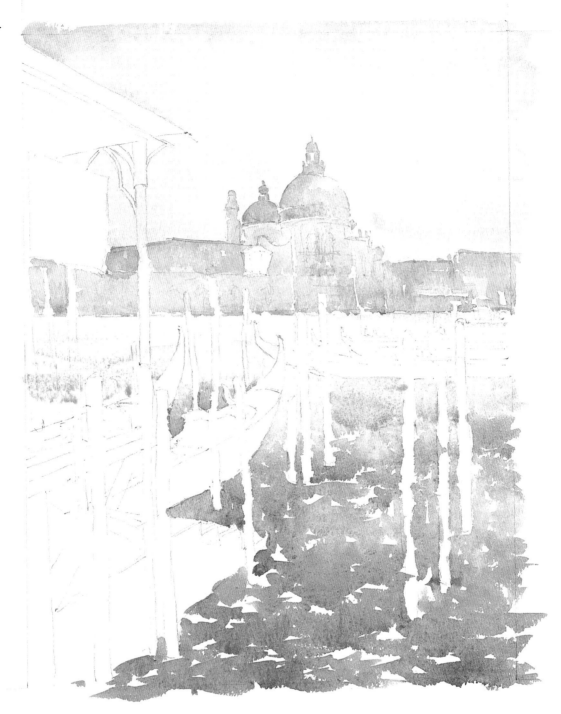

Second stage

When the sky was dry, using a varying mix of French Ultramarine, Crimson Alizarin, Yellow Ochre and plenty of water, I painted in the background buildings. When you do this, let the colours run together – wet-on-wet. I did this with my No. 6 sable brush and also used the same brush and technique to do the water. Then, with a wash of Coeruleum and Cadmium Yellow Pale, I started painting the water under the buildings and worked down, changing the colours gradually to French Ultramarine and Hooker's Green Dark, with a little Crimson Alizarin added in. You will see that I didn't attempt to put clean edges on the posts. Notice also the amount of white, unpainted paper I left for 'dancing light' on the water.

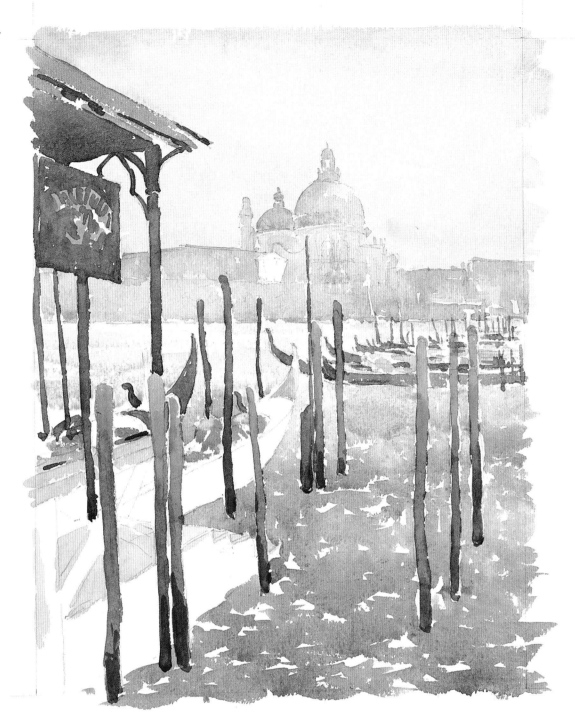

Third stage

Having let the water dry, I painted in the light colours on the gondolas and the 'black' of the hulls. All this stage was done with my No. 6 sable brush. The structure on the left and the posts were next. I started with the green top. Then I painted Yellow Ochre on the sign underneath this, adding more water. Next, I painted the top of the steps. When these were dry, I painted the very dark area under the green top, the sign, and the dark posts. Then, with a mix of Yellow Ochre, Crimson Alizarin and a touch of French Ultramarine, I started at the top of the light posts, letting the paint run wet-on-wet down them, getting darker towards the bottom.

Finished stage

I started by painting in the dark posts and gondola in the foreground. I added more darks to the posts at the bottom, using Hooker's Green Dark and Crimson Alizarin. Then, using the same colour and adding French Ultramarine, I painted in the reflections. This was done with broken, short brush strokes using my No. 6 sable brush.

I then painted in the lamp, and this helped to push the background buildings further back. Finally, I darkened under the green roof and the structures and posts. Remember, you can't paint any of these demonstrations exactly like mine, I couldn't do them exactly the same again, either. So, when you have finished a demonstration, add any darks or accent that will help *your* painting – but don't fiddle!

▼ **Venice**
watercolour on
Bockingford watercolour
paper 200 lb Not
30 x 23 cm (12 x 9 in)

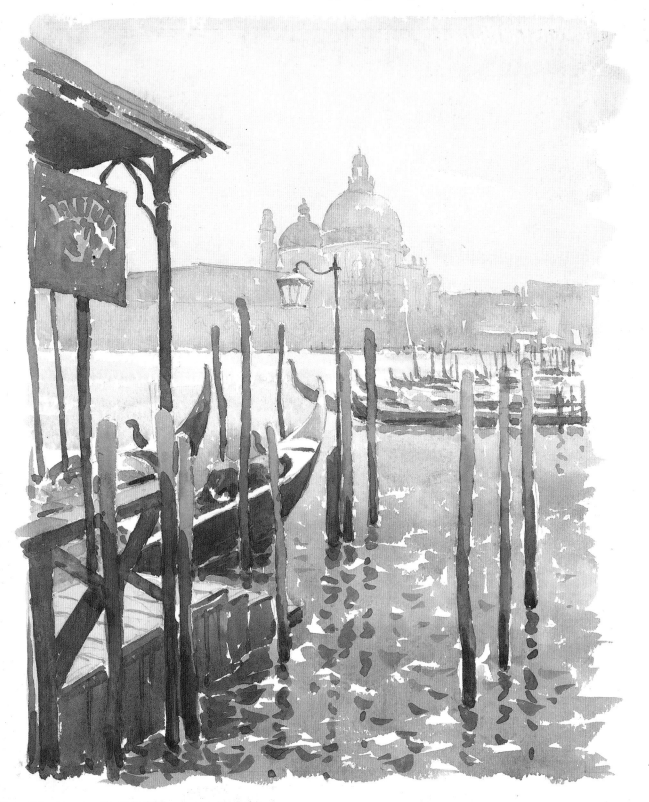

ELEANOR
OF AQUITAINE

THE QUEEN WHO RODE OFF TO BATTLE

ANN KRAMER

QED Publishing

CONTENTS

A NOBLE CHILDHOOD

TEENAGE QUEEN

ANOTHER COUNTRY

3

PRISONER AND STATESWOMAN

4

A NOBLE
CHILDHOOD

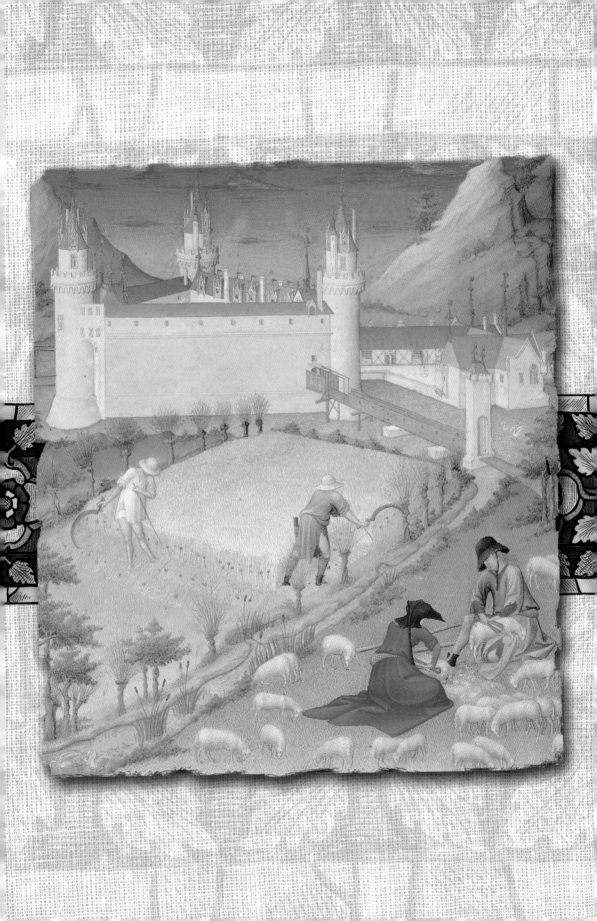

Noble Birth

Above: This medieval illustration shows a troubadour strolling through the countryside. Troubadours were poet-musicians who wrote and sang love poems that were popular in the 1100s.

Previous page: Peasants harvest crops and shear sheep in front of Poitiers Castle in a detail from a 15th-century illustrated manuscript.

Eleanor of Aquitaine lived more than 800 years ago. At a time when women had few rights, she became queen of France and England, and one of the most powerful women of her time.

Eleanor was born in 1122 in the duchy of Aquitaine, a huge region in the southwest of what is now France. She came from a privileged and noble background. Eleanor's father was William X, duke of Aquitaine. He was a tall, imposing man, who was often quick to quarrel. Eleanor's mother was called Aenor. Historians know very little about Aenor, but she was the daughter of a strong-willed woman called Dangerosa, the viscountess of Châtellerault. Eleanor had a younger sister, Petronilla, and a brother, William Aigret.

Eleanor's grandfather died when she was about four or five, but his adventures made a strong impression on her life. He was William IX, duke of Aquitaine. Like her father, he was powerful and wealthy. He was also a cultured man who wrote music and poetry that Eleanor would have heard when she was a child. He was probably the first *troubadour*, or poet-musician.

1094
Eleanor's grandfather, William IX, marries Philippa. Their son, William (b. 1099), will be Eleanor's father.

1095
Pope Urban II urges European Christians to take Jerusalem from Muslim Turks.

Eleanor's grandfather divorced his first wife, Ermengarde, then married again, to a woman named Philippa. They had seven children, one of whom was Eleanor's father. Her grandfather then fell in love with Dangerosa, who was also married. He kidnapped her and brought her to his castle. In 1121, his son married Dangerosa's daughter from her previous marriage, Aenor. Eleanor was their first child.

Below: Eleanor's home was the great palace at Poitiers in the duchy of Aquitaine.

Eleanor's birth

There is very little information about Eleanor's early life. Historians do not know exactly where or when she was born. She was probably born in April 1122, either in Poitiers or the castle of Ombrière in Bordeaux. She was named alia-Aenor, which is Latin for 'the other Aenor', or Eleanor in English.

1096

Thousands of European Christians travel to the Holy Land on the First Crusade.

1099

The First Crusaders seize Jerusalem.

Aquitaine

Eleanor grew up in Aquitaine. She always loved the duchy. It was a sophisticated region and the source of her family's wealth and importance. When Eleanor was born, her family's domains stretched from the Loire River in the north to the Pyrenees mountains on the Spanish border in the south, and the mountains of the Massif Central in the east to the Atlantic Ocean in the west.

Aquitaine was a warm, fertile region containing mountains and forests, meadows, vineyards and olive groves. The duchy had plenty of villages, farms, small walled cities, castles, monasteries and ports.

Left: The map shows France and England as they were in the 1100s. It includes Eleanor's homeland of Aquitaine and the kingdom of France. It shows many of the French and English places Eleanor visited during her life. France was then a small kingdom, surrounded by counties and duchies that often fought each other. Aquitaine was the largest.

1100

The great abbey of Fontevrault is founded, with money given by William IX.

1121

Eleanor's father marries Aenor, the daughter of Dangerosa.

Eleanor's ancestors had ruled Aquitaine for 300 years. Their home was the castle of Poitiers, an ancient walled area and capital of Poitou, Aquitaine's most important county. The dukes of Aquitaine were powerful, but the king of France was their overlord. They owed him allegiance, although they often rebelled. France then was only a very small kingdom. Eleanor's father, as duke of Aquitaine, had more land and vassals (nobles who owed him allegiance) than Louis VI, who was king of France at the time.

The people of Aquitaine were known for being brave, witty and independent. Members of their nobility lived a more luxurious lifestyle than those in the north. The noblewomen of Aquitaine had often had a little more freedom than noblewomen in other parts of France. Eleanor heard stories of many strong-minded women from history, such as her grandmother, Dangerosa. These women made powerful role models.

Below: Aquitaine was a beautiful area with many castles and an ancient history. The Romans called it Aquitainia, meaning 'land of waters', because of its many rivers.

1121

Louis VII, future king of France, is born. He is the second son of Louis VI, known as Louis the Fat.

1122

Eleanor of Aquitaine is born either in Poitiers or Bordeaux.

Medieval Society

The Middle Ages was a period in European history that lasted from the fifth century to the 15th century. It is also called the medieval period. Life was very different from today. People did not vote and there were no central governments – kings and nobles held the power, and land was the basis of wealth. In England and France, a system that historians call feudalism governed society. Kings gave land to nobles and knights, who promised to serve them. Europe was split into kingdoms, ruled by royalty; duchies, ruled by dukes; and smaller counties, ruled by counts. There were few towns, and most people lived in the countryside. But by Eleanor's time, towns and trade were developing.

KING

NOBLES

KNIGHTS

PEASANTS

FEUDAL SOCIETY

The king was at the top of medieval society. He granted land, called fiefs, to powerful nobles, called vassals, who swore allegiance and agreed to serve him. Vassals granted land to lesser nobles and knights, who swore allegiance to them and provided military service. Knights were the warriors of feudal society. They were obliged to serve their lords for 40 days every year.

Left: A medieval knight swears an oath of loyalty.

Right: A peasant woman working in the fields. Peasants were at the very bottom of medieval society. Their land, homes, food and animals belonged to their lord. In exchange for working the land, they could keep some of the food they produced. Peasant women raised children, spun wool and laboured in fields.

Left: Women had few rights in the medieval world, but noblewomen (left) had a little more power than peasant women. They could inherit and own land. But when a woman married, she lost all rights over her property, which went to her husband. A woman's role was to honour, obey and serve her husband. However, many noblewomen ran households and family estates while their husbands were away fighting.

Above: Pope Urban II (1035–99) blesses a church in Cluny, France. In medieval Europe, Christianity ruled everyone's lives. The pope was the head of the church and was thought to be God's representative on Earth. He had the power to punish people by banning them from the church.

Life in the Great Hall

When Eleanor was a child she spent a lot of time in the castle at Poitiers. It was her family home and a mighty fortress. Poitiers Castle was already several centuries old when Eleanor was born. It stood high on a cliff and had thick stone walls capable of repelling the fiercest invaders. Soldiers stood guard on the high walls around the castle, called ramparts.

The family lived in apartments in the Maubergeonne Tower, which had been built by Eleanor's ancestor, William VII. There are no detailed descriptions of how Eleanor spent her childhood, but life in the palace would have been exciting, with visitors coming and going and messengers bringing news from around Aquitaine.

In the summer, Eleanor and Petronilla played in the beautiful palace gardens, which were full of fruit trees. In the evenings, everyone gathered in the great hall to eat and be entertained.

Left: The nobility enjoyed lavish banquets, or feasts. Meat included venison, swan, goose, crane and even peacock. Sauces were highly spiced. They ate lobsters and oysters, and a variety of sweet puddings and fruits, all washed down with wine. People ate with knives and their hands because there were no forks.

1125
Eleanor's sister, Aelith, is born. She was usually known as Petronilla, which is Latin for 'Younger Sister'.

1126
Rochester Castle is built in England, one of many great buildings to be constructed during the 12th century.

Right: A medieval conjurer produces a rabbit. Acrobats, jugglers and musicians entertained not just in noble courts but also at festivals and feasts.

A large fire in a huge fireplace provided heat. Clean rushes covered the bare wooden floors. Candles were used for light.

Poitiers was the cultural centre of western Europe. Eleanor would have seen skilled entertainers, many of whom travelled from castle to castle throughout Europe. There would have been jugglers and acrobats, and puppet masters who worked puppets called marionettes. Eleanor would have listened to musicians who played stringed instruments, flutes and small drums, called tabors. There would also have been minstrels, called *jongleurs*, storytellers and troubadours, who sang about women and love. When Eleanor was very young, she would have heard her grandfather singing the love poems and songs he had written himself. She developed a love of music that lasted her whole life.

Castle hygiene

There were no flush toilets in medieval Europe. Instead, people used what was called a privy. Most castle privies consisted of a wooden or stone seat over a long shaft that emptied into the castle moat. People took baths in wooden tubs, which could be moved near the fire for warmth.

1126

Averroës is born in Muslim-ruled Córdoba, Spain. He becomes one of the greatest Islamic thinkers.

1126–27

Eleanor's brother, William Aigret, is born. Historians are not sure of the exact date of his birth.

A Lively Girl

Eleanor was a bright, intelligent and lively young girl. She was also well educated, which was unusual for the time. The majority of girls in the Middle Ages did not have much formal education. There were few schools – and they were not intended for girls.

Girls were supposed to learn how to be obedient wives and good mothers. They needed to know how to run a home, but reading and writing were not considered important skills for most of them.

Eleanor, however, had a privileged upbringing. Unlike many other girls, she was carefully educated and taught a range of different skills. She was quick-witted, strong-willed and probably rather spoiled. From her mother, and perhaps her grandmother too, she learned traditional women's skills such as sewing and embroidery. She was taught how to run a huge household. Aenor would have taught many young girls, not just her own daughters. It was the custom for the daughters of noble families to be sent to wealthier households for instruction.

Above: Medieval children playing blind man's bluff. Children in the Middle Ages played games like hide and seek, chanted rhymes and played with toys.

1127

In England, the barons accept Matilda, daughter of King Henry I, as heir to the English throne.

10 February 1127

Eleanor's grandfather, William IX, dies. Eleanor's father becomes William X, duke of Aquitaine.

Above: A woman and man riding together. The man has a hawk on his arm. Girls of the nobility learned to ride at an early age. Hunting with hawks was a popular sport for noblewomen.

Eleanor was also taught how to read Latin, probably by the castle clergyman. Latin was the language of learning. She also learned to read *Provençal*, a type of French spoken in Aquitaine. Reading and writing were seen as separate skills in the Middle Ages, and many people who were taught to read could not actually write. Historians think this was the case with Eleanor.

Eleanor always loved the arts, especially poetry and literature. She played the harp and enjoyed singing and dancing. She learned to play board games, such as chess, which had recently arrived in Europe from the East. She was also taught to ride and to hunt with birds of prey called falcons that could be trained to hunt small creatures. She rode well and liked to ride with her legs on either side of the horse, rather than sidesaddle, which was how most women rode at the time.

How we know

Since Eleanor probably could not write, she did not keep a diary or write personal letters. She would have used a scribe for official letters. Most of what we know about her life comes from people who wrote about her, sometimes much later. In the 1170s, the troubadour Richard le Poitevan said Eleanor was 'reared with an abundance of all delights, living in the bosom of wealth'.

1128

Matilda, daughter of Henry I, king of England, marries Geoffrey Plantagenet, the count of Anjou.

1128

The pope formally acknowledges the Knights Templar, a group of soldier monks who fought in the crusades.

TEENAGE
QUEEN

2

Ciomorent les faic du Roy loye filz du
Roy loye le que cammenrament Et lan

A Travelling Court

Like other medieval rulers, Eleanor's father had a travelling court, and Eleanor travelled extensively with her father around Aquitaine. From these travels she was able to learn how the duchy was governed. Every year, her father gathered up his family and rode through his domain to check on his vassals and to collect taxes or crops owed to him. Eleanor went with him, as did the whole household, including scribes, knights, musicians, chaplains, clerks, cooks and other servants.

Above: Louis II (1377–1417), duke of Anjou, enters Paris. Monarchs and rulers, like Eleanor's father, travelled through their lands accompanied by nobles, knights and servants.

Previous page: This medieval illustration shows two scenes from Eleanor's life: her marriage to Louis (left) and her journey to the Holy Land (right).

The duke's household travelled from one end of Aquitaine to another, setting up court in castles and keeps around the duchy. William's vassals provided food and lodging. Eleanor saw her father conducting business in every part of Aquitaine. They often stayed in the palace of Ombrière in Bordeaux. Here, Eleanor watched her father receive his vassals, sign documents or petitions, settle disputes and administer the duchy.

1129

Eleanor's name appears on a document for the first time. She signs her name with a cross, because she cannot write.

1130

Eleanor's mother, Aenor, and brother, William Aigret, die.

Left: Great nobles had to provide feasts and accommodation for Eleanor's family during their travels. It was a costly business entertaining the noble household.

Eleanor had an official role. When she was about seven, she witnessed a document granting privileges to monks in the Abbey of Montierneuf, where her grandfather was buried. She wrote a cross in ink next to her name, probably using a quill pen.

Eleanor's father was impulsive and quarrelsome. In 1130, he quarrelled with the church over who should be the next pope. Eleanor's father supported Anacletus II, a cardinal who was challenging the existing pope, Innocent II. William drove all the churchmen who supported Innocent out of Aquitaine. As a result, Bernard de Clairvaux, a powerful and influential cleric, banned, or excommunicated, him from the church.

Also in 1130, Eleanor's mother and little brother died, leaving Eleanor and her sister as the sole surviving children. Her brother, as a boy, had been her father's heir, but now Eleanor was next in line to inherit the duchy of Aquitaine.

Punished by the church

Excommunication meant a person was banned from the Catholic church and could not take part in church services. It was a harsh punishment – the church said that the soul of an excommunicated person was damned.

1131

Louis, the second son of King Louis VI of France, becomes heir to the French throne when his elder brother dies.

1133

Eleanor's uncle, Raymond of Poitiers, goes to the Holy Land to become ruler of Antioch.

Wealthy Heiress

After their mother's death, Eleanor and her sister were left to their own devices. Always argumentative and impatient, Eleanor's father was caught up in his own problems.

Aquitaine was rarely at peace: some of William's vassals were showing signs of rebelling against him. There was also no sign of an end to his quarrels with the church. In 1135, when Eleanor was 13, William stormed into a church where Bernard de Clairvaux was celebrating mass. Bernard confronted the excommunicated William, who suffered a seizure or fit and collapsed. When William recovered, he repented for quarrelling with the pope. William also became depressed. He wanted a son to inherit his lands, and decided to marry again.

He chose Emma, countess of Limoges. She held power over Limousin, a small province of Aquitaine.

Left: This 14th-century manuscript shows King Louis VI of France (1081–1137) watching builders work. He was known as Louis the Fat because he was very large. His first son died in 1131 and his second son, Louis, became his heir.

1135
William X makes peace with the church. He founds an abbey as an act of penance.

1136
William X proposes to Emma, countess of Limoges, but she is kidnapped and married to the count of Angoulême.

Nobles in Limousin wanted to stop William from gaining more power over them. They kidnapped Emma and forced her to marry the count of Angoulême. Surprisingly, William did not fight back.

Left: Medieval women putting on their finery. By the age of 15, Eleanor was very beautiful. She loved to wear elegant clothes and jewellery.

In 1137, William decided to make a pilgrimage to the church of St James at Santiago de Compostela in Spain. Eleanor and Petronilla went with him as far as Bordeaux, where William left them with the archbishop, one of his loyal vassals. He told Eleanor he would return wearing a cockleshell badge, the symbol of St James. With just a few knights and servants, William arrived in Spain. There he became ill, and, realizing he was dying, he bequeathed Aquitaine to Eleanor and put the duchy and Eleanor under the protection of King Louis VI of France. Then William died. Back in Bordeaux, Eleanor was now duchess of Aquitaine, Poitou and Gascony, and a wealthy landowner.

A pilgrim's badge

Bands of pilgrims were a common sight during the Middle Ages. Many people went on pilgrimages – long journeys by land and sea – to places such as Rome or Compostela, where there were sacred relics. They hoped to receive forgiveness for sins, or miracle cures for illness. Those who went to Compostela wore a metal cockleshell-shaped badge.

1136
William commands the nobles of Aquitaine to swear loyalty, or fealty, to Eleanor.

10 April 1137
William X dies while on pilgrimage. He is buried at the cathedral in Compostela, Spain.

Marriage

Eleanor's life changed completely after her father died. Almost immediately, Louis VI arranged for Eleanor to marry his son, who was also named Louis. Eleanor was 15 years old and Louis was 16.

Louis VI was seriously ill near Paris when news reached him that his most powerful vassal, William X, had died. Swiftly, he made plans for his son Louis to marry Eleanor. Gaining control of Aquitaine would increase France's land and influence. Eleanor was at Ombrière, heavily guarded in case an ambitious noble tried to kidnap her. We do not know how she felt about her father's death or the marriage plans.

In June, young Louis left Paris for Aquitaine. With him went 500 knights; great lords; the king's chief minister, Abbot Suger; and mules laden with tents, cooking equipment, gold and jewels. Their journey took about a month. It was hot, and the huge procession often travelled by night.

Left: Statues of Eleanor and Louis in Chartres Cathedral, France. The young couple were very different. Louis was indecisive and deeply religious. Eleanor was confident and bold.

April 1137
Eleanor inherits Aquitaine, Poitou and Gascony. She is the wealthiest heiress in western Europe.

18 June 1137
Louis VI sends his son, Prince Louis, to Bordeaux to marry Eleanor.

Louis reached Ombrière in July and set up camp near the Garonne River. With its colourful pavilions and many knights, the royal camp was a glorious sight. Louis was ferried across the river to the castle, and Eleanor met her husband-to-be for the first time. A few days later, they were married in the cathedral of St André in Bordeaux.

After the wedding, Eleanor and Louis travelled through Bordeaux, passing houses hung with tapestries and banners. There was a wedding banquet at Ombrière. The couple then went to Poitiers, where celebrations continued and Eleanor's vassals arrived to swear allegiance.

Not all of Eleanor's vassals were pleased, and some stayed away. One was William de Lezay. Louis and his knights set off to punish him. There was a violent confrontation and many of the rebels were slaughtered.

An arranged marriage

Parents from noble families arranged marriages to increase their power. When Eleanor's father died, Louis VI was her overlord and chose his son to become her husband.

Above: Eleanor gave this rock crystal and gold vase to Louis as a wedding present. The vase is the only one of Eleanor's possessions to survive. It is in the Louvre museum in Paris.

29 June 1137

Prince Louis and his retinue arrive in Limoges. They reach the Ombrière Palace on 11 July.

25 July 1137

Eleanor and Louis are married in Bordeaux. They are made duchess and duke of Aquitaine.

Queen of France

In August 1137, Eleanor and Louis left Aquitaine for Paris. News came that Louis VI had died. Suddenly, Eleanor's husband was king of France, and she – a teenager – was queen.

Below: This medieval stained-glass window from Chartres Cathedral shows carpenters at work. Many great cathedrals were built in France during the 12th and 13th centuries. They had soaring spires and arched stained-glass windows.

Eleanor was crowned queen on Christmas Day, 1137. Her new home was the Cité Palace in Paris. It was a grim tower, with small, drafty rooms. Her new husband was devoted to her, but he was even more interested in religion. For high-spirited Eleanor, life was rather dull after Aquitaine. She had brought noble ladies and troubadours with her, and tried to recreate the liveliness of Aquitaine in her Paris home. The French criticized her extravagant lifestyle. Marriage to Eleanor brought problems for Louis. Back in Poitiers, some of Eleanor's nobles rebelled against French control. Eleanor's sister, Petronilla, became involved with a married count, Raoul of Vermandois. Raoul's wife was the sister to Count Theobold of Champagne. Louis arranged a divorce for Raoul so he could marry Petronilla. Theobold was furious.

August 1137
Louis VI dies. Eleanor's husband, Louis, succeeds him as Louis VII, king of France.

25 December 1137
Eleanor is crowned queen of France.

He protested to the pope, who excommunicated Petronilla and Raoul. In revenge, Louis led an army against Theobold. His forces attacked the count's castle in Vitry. They launched flaming arrows at the castle, which was wooden and caught fire. Terrified people sought safety in a wooden church nearby and were burned alive when that caught fire as well.

Eleanor tried to bargain with the powerful Bernard de Clairvaux. She offered to persuade Louis to make peace if Bernard would encourage the pope to lift her sister's excommunication. Bernard ordered her to stop interfering in state affairs; her duty was to be an obedient wife and produce sons. Cleverly, Eleanor pleaded that her greatest wish was indeed to have children. She won his sympathy and he helped to arrange a peace treaty.

Below: The abbey of St Denis, near Paris, today. Abbot Suger had this splendid abbey built to replace a much older church. In 1144, Eleanor and Louis attended its dedication.

A palace makeover

Eleanor changed the royal palace in Paris. She ordered slit windows to be widened to let in more light, and had a huge fireplace built. She also introduced table manners: tablecloths and napkins were used and pages had to wash their hands before serving food.

1142–43

Louis wages war against the count of Champagne. He suffers remorse when 1,000 people are burned alive.

1145

Eleanor's first surviving child, Marie, is born. Eleanor had been pregnant before, but the baby died at birth.

Crusades

Above: Pope Urban II meeting with the clergy in 1095. He called on Christians to make a Holy War to free Jerusalem from Muslim Turks.

In 1095, Pope Urban II called on Christians to march to the Holy Land and take control of Jerusalem from the Muslim Turks. Then, just as today, Jerusalem was a holy place to Christians, as well as to Muslims and Jews. Thousands of Christians from all over Europe and all walks of life responded and set off on what became known as the First Crusade. Between 1096 and 1270, there were eight crusades. They took their name from the Latin word *crux*, meaning 'cross', which every crusader wore. The First Crusaders captured Jerusalem and set up Christian kingdoms in the Holy Land. These kingdoms were Jerusalem, Antioch, Edessa and Tripoli. The kingdoms came under constant attack and, in 1187, the Muslim leader Saladin recaptured Jerusalem. Other crusades followed, with Jerusalem being regained and lost once more. In 1291, the last Christian stronghold, Acre, fell to the Muslims.

Right: This map shows Europe and the Holy Land in the 12th century. Crusaders, including Eleanor, travelled by land or sea from Europe to the Middle East. It was a long and dangerous journey. Many died on the way.

ENGLAND
London

St. Denis
Paris

FRANCE
Poitiers

AQUITAINE

Santiago de Compostela

NAVARRE

Pyrenees

CASTILE

SPAIN

TIMELINE

1096–99 FIRST CRUSADE
Christians capture Jerusalem and set up Christian kingdoms on the Syrian coast.

1147–49 SECOND CRUSADE
Louis VII and Conrad III of Germany lead the crusade, which is a failure. Eleanor goes with Louis.

1189–92 THIRD CRUSADE
Christians take Acre, but Muslims keep Jerusalem. Eleanor's son, Richard I, is one of the leaders of the crusade.

1202–04 FOURTH CRUSADE
Crusaders loot Constantinople (Istanbul).

1212 CHILDREN'S CRUSADE
Thousands of children cross Europe. Most die of hunger or disease. Many are sold into slavery.

1217–21 FIFTH CRUSADE
Crusaders capture and lose land in Egypt.

1228–29 SIXTH CRUSADE
A truce is declared.

1248–54 LOUIS IX'S FIRST CRUSADE
The French capture Damietta briefly.

1270 LOUIS IX'S SECOND CRUSADE
Louis IX of France dies on crusade.

Left: Crusaders attack Antioch, Syria, during the First Crusade. After an eight-month siege, the city fell in 1098. The image comes from a history of the crusades written by a French archbishop, William of Tyre (about 1130–85). It shows crusaders using ladders to scale the walls.

GERMANY

Worms

Ratisbon

HOLY

ROMAN

—— Alps

EMPIRE

Rhine

ITALY

Vienna

ELEANOR'S ROUTE TO JERUSALEM

Danube

Black Sea

Rome

Constantinople

Bosphorus

BYZANTINE EMPIRE

Edessa

Palermo

Barbary Coast

SICILY

Calabria

Attalia

Antioch

Mediterranean Sea

ELEANOR'S ROUTE HOME

Tripoli

Acre

Damascus

Jaffa

Jerusalem

Damietta

Right: The Dome of the Rock, Jerusalem. A magnificent mosque, the Dome of the Rock is sacred to Muslims. It was built in the 7th century. During the crusades, Christians and Muslims fought for control of Jerusalem.

Crusading Queen

In 1146, the pope called for a crusade. Muslim Turks had seized Edessa and were threatening Christian-held Jerusalem and Antioch. Louis decided to lead the Holy War, and Eleanor announced that she would go too.

Below: Bernard de Clairvaux preaching the crusade to a huge number of people at Vézelay, in 1146. So many people demanded a cross – the emblem of the crusade – that Bernard cut his white robe into strips to make cloth crosses.

Eleanor was 24 and she had a young daughter, but life in Paris was boring and a crusade would be a big adventure. When Bernard de Clairvaux preached the crusade at Vézelay, she and Louis took the cross with enthusiasm. She went to Aquitaine, where she recruited 1,000 of her vassals and knights, the largest fighting force recruited from any one region. She also raised money by organizing tournaments and granting privileges to religious houses in exchange for gold.

11 June 1147
Eleanor and Louis leave St Denis on the Second Crusade at the head of a huge army.

3–16 October 1147
Eleanor and Louis stay in Constantinople, the glittering capital of the Byzantine Empire.

Right: This metal engraving shows crusaders travelling by ship to the Holy Land. It was created in the 12th century and is found in St Mark's Basilica in Venice.

A likely story

It is said that Eleanor and her women rode through the crowds at Vézelay on white horses, dressed like women warriors called Amazons. They waved their swords and urged people to join the crusade. It is a colourful story but there is no proof it happened.

In 1147, Eleanor and Louis set off from St Denis with a vast army of some 100,000 people. Their daughter stayed at home. Eleanor rode near the front with her vassals and luggage. With her travelled other noblewomen and 300 women of lesser rank. Louis and his soldiers brought up the rear.

Travelling between 10 and 20 miles (15–30 km) a day, the huge procession wound its way through Germany and Hungary. In October, they reached Constantinople, now called Istanbul. Eleanor had never seen anything like this city, with its exotic spices, tiled pathways and glorious fountains.

The crusaders crossed the Bosphorus into Asia. Travelling was difficult, the weather worsened, and food supplies ran low. Eleanor traded jewellery for food. Louis decided to take the crusade over the mountains to Antioch. Turkish forces harassed them constantly. Eleanor and her women travelled in horse-drawn litters with thick leather curtains for protection.

January 1148
Eleanor arrives in Attalia, Turkey

19–28 March 1148
Eleanor and Louis stay in Antioch with Eleanor's uncle. Louis forces Eleanor to travel to Jerusalem.

Above: This 15th-century painting by Jean Fouquet portrays the entry into Constantinople of Louis VII along with the king of Germany, Conrad III (1093–1152).

Disaster struck on a mountain pass when Eleanor and her vassals ignored instructions and went ahead to find a better place to camp, leaving the main army dangerously exposed. Turkish forces made a surprise attack and Louis' army suffered terrible losses. More than 7,000 crusaders were killed. The French blamed Eleanor and her vassals for having left them unprotected.

Louis changed his mind and decided to continue to Antioch by sea. He and Eleanor set sail from the port of Attalia. Three weeks later, after a stormy and dangerous voyage that should only have taken three days, they arrived in Antioch. Eleanor's uncle, Raymond, ruler of Antioch, came to greet them. Eleanor was thrilled. Raymond was 36, a handsome, decisive warrior, quite different from Eleanor's husband. Eleanor and Louis stayed in Raymond's palace and were entertained lavishly. Raymond and Eleanor spent time together and there was gossip; Louis became jealous. Raymond wanted Louis' army to help him attack Edessa. Louis refused and he told Eleanor that they were leaving for Jerusalem. There was an argument and Eleanor threatened to stay and put her forces at Raymond's service.

Early summer 1149

Eleanor and Louis leave Acre in separate ships. Eleanor is captured briefly. Her ship is blown off course.

July–August 1149

Eleanor joins Louis in Calabria. They leave overland for France.

She was tired of her weak husband. She told him that she wanted a divorce. Louis acted swiftly. His soldiers seized Eleanor by force, and they left secretly for Jerusalem. Eleanor was furious and disgraced.

Finally, they arrived in Jerusalem, where Louis did penance. Against all advice, he attacked the Muslim-held city of Damascus. It was a serious misjudgment because Damascus was friendly to Christians, but Louis was greedy for land and did not understand the situation. His forces besieged the city but were forced to retreat, with considerable loss of life. The crusade was a failure: it had done nothing to strengthen the Christian position in the Holy Land. The French were humiliated and their soldiers were deserting.

In 1149, Eleanor and Louis began the long journey home. They sailed from Acre in separate ships, bound for southern Italy. While at sea, Greek forces attacked, intending to take Eleanor and Louis hostage. Eleanor's ship was captured briefly, but Sicilian forces drove off the attackers. Storms drove the ships apart and Eleanor was possibly shipwrecked on the Barbary Coast. She rejoined Louis in Calabria, Italy, and they continued overland.

The journey home was slow and Eleanor was often ill. Louis and Eleanor stayed with the pope in Rome and told him of their marriage problems. He refused a divorce and urged them to resolve their differences. Eleanor and Louis finally arrived in Paris, nearly two and a half years after leaving.

> *'Gracious, lovely, the embodiment of charm… one meet [suitable] to crown the state of any king…'*
> **A description of Eleanor by Bernard de Ventadour, troubadour, 1153**

9–10 October 1149
Eleanor and Louis visit the pope in Rome, Italy. Their marriage is unhappy. The pope urges them to make up.

November 1149
Eleanor and Louis arrive back in Paris, France.

ANOTHER COUNTRY

Divorce and Remarriage

Eleanor and Louis returned to Paris during a bitter winter. They quarrelled frequently and Eleanor still wanted a divorce. She said she had married a monk, not a king. In 1150, Eleanor gave birth to a second daughter, but Louis really wanted a son and heir.

In Antioch, Eleanor had said their marriage was cursed. Now Louis began to think she was right. Abbot Suger tried to keep them together – the loss of Aquitaine would leave France weak – but many of Louis' nobles thought Eleanor meddled too much and wanted him to divorce her. After Suger died in 1152, Louis finally agreed to divorce.

Louis had other matters to settle. Two of his powerful vassals – Geoffrey, count of Anjou, and Geoffrey's son, Henry, duke of Normandy – were challenging his authority. Louis summoned them to Paris.

Previous page: A man looks adoringly at the woman he loves in this symbol of courtly love.

Left: Bishops grant Louis VII his divorce. The official grounds for the divorce were that Louis and Eleanor were too closely related – they were fourth cousins. Husbands and wives being related was not unusual, however. All the European royal houses were related to each other.

1150
Eleanor's second daughter, Alix, is born.

August 1151
Geoffrey of Anjou and his son Henry visit Eleanor and Louis in Paris.

He demanded that Henry should pay him homage – a formal oath of allegiance. At first, father and son stormed out. Later, they returned and Henry pledged allegiance, placing his hands between Louis' palms.

Eleanor was attracted to Henry. At 17, he was 11 years younger than she was, and he was a forceful, handsome young man. She decided that, once divorced, she would marry him.

Narrow escapes

As a single, wealthy woman, Eleanor was not safe. There were two attempts to kidnap her in the weeks after her divorce. Theobold of Champagne made the first attempt. Warned in time, Eleanor fled under cover of darkness. Henry's younger brother Geoffrey made the second attempt. Again, Eleanor was warned and got away.

Eleanor and Louis were divorced in Aquitaine. It was almost unheard of for a woman to get a divorce – it was a husband's decision – but Eleanor had done it. Louis and the French left Aquitaine, and Eleanor's vassals renewed their allegiance to her. Custody of her daughters, Marie and Alix, was given to their father, as was usual at the time.

Eleanor sent a message to Henry. He came to Aquitaine, where they married secretly. Louis was horrified when he heard. Eleanor had married his most powerful rival. Henry's father had just died and he had now inherited Anjou.

Left: Geoffrey, count of Anjou, the father of Henry, duke of Normandy, Eleanor's second husband.

21 March 1152

Louis and Eleanor are divorced. Marie and Alix stay with Louis. Eleanor regains control of Aquitaine.

18 May 1152

Eleanor secretly marries Henry of Anjou, also known as Henry Plantagenet.

Queen of England

Eleanor and her new husband had much in common. They were both ambitious, dynamic and brave. Their combined lands made them powerful, and Henry had a claim on the English throne. Henry's mother was Matilda, daughter of King Henry I of England. When Matilda's father died in 1135, she was in Anjou and pregnant. This gave King Henry's nephew, Stephen of Blois, the chance to seize the English throne. England was plunged into civil war, but Stephen was victorious.

After he heard about Eleanor and Henry's marriage in May 1152, a furious Louis led an army against Normandy. Henry and his forces responded swiftly and forced Louis to surrender and make a truce. In August, Eleanor and Henry travelled through Aquitaine to meet their vassals.

The Plantagenets

Henry was known as Henry Plantagenet. His nickname came from the sprig of yellow broom he wore in his hat. The plant's Latin name was *planta genista*. The Plantagenets would rule England for more than 300 years.

Above: Eleanor and Henry's sea crossing from France to England was dreadful. There were terrible storms. It took them 24 hours to cross the English Channel. Eleanor was pregnant again, and holding her first son.

January 1153

Henry leaves Eleanor in Aquitaine and invades England. He returns in April 1154 as heir to the English throne.

1153

Eleanor's first son is born. He is baptized William, after the dukes of Aquitaine, and titled count of Poitiers.

Some were suspicious of Henry. When people in Limoges failed to provide enough food for his court, he flew into a terrible rage and ordered the town's walls to be torn down.

Henry left for England with an army to pursue his claim to the throne against Stephen. He left Eleanor in charge of Aquitaine and Anjou. She busied herself granting privileges and money to monasteries and abbeys. While Henry was away, she gave birth to their first son, William.

Henry's English campaigns were successful. He rampaged through England, taking towns and castles, until he confronted King Stephen. Stephen made peace and agreed that Henry would inherit the crown when he died, rather than Stephen's own sons.

Henry returned to Normandy, where Eleanor joined him with their new son. In 1154, news came that Stephen had died. Henry was now the English king, and they prepared to travel to England.

At first, the weather was so bad that they could not sail. Eventually, they made the crossing and went to Winchester, where nobles swore allegiance to Henry. Cheering crowds greeted them at Westminster Abbey in London, where they were crowned king and queen of England.

Left: Westminster Abbey, London, England. Henry and Eleanor were crowned king and queen of England here in great splendour.

1154
Louis VII remarries, to Constance, daughter of Alfonso VII, king of Castile, Spain.

19 December 1154
Henry and Eleanor are crowned king and queen of England in Westminster Abbey, London.

Affairs of State

Eleanor and Henry now ruled over a huge area. Known as the Angevin empire, it stretched from Scotland to the Pyrenees. Henry's first task as king was to restore peace to England, which had suffered civil war during Stephen's reign. Within a year, he ended rebellions and began to restore law and order. His legal reforms laid the foundation for English common law, which continues to this day.

Henry was always on the move. Like Eleanor's father, he had a travelling court, which moved from one palace or castle to another. He took his treasury and royal officials with him, setting up official courts wherever he stayed. Eleanor often travelled with her husband, bringing their children and members of her own royal household. Henry was often away from England, warring to extend his lands or checking on affairs in Aquitaine, Normandy and Anjou. While Henry was away, Eleanor governed England in his name.

Right: A travelling court included horses, wagons, baggage carts and pack animals, laden with luggage of all kinds. There were at least 200 people in the royal household, all on the move.

February 1155
Eleanor's second son, Henry, is born in London.

1155
Henry makes Thomas Becket chancellor of England. They become close friends.

> 'God save Lady Eleanor, Queen, who is the arbiter of honour, wit, and beauty, of largesse and loyalty. Lady, born were you in a happy hour and wed to Henry, king.'
>
> **The poet Philippe de Thaün, about 1154**

Henry was the absolute ruler, but Eleanor carried out some official business too – it was very different from her marriage to Louis, when she had had no say in government. Eleanor spent some time in London, but also travelled the country, presiding over courts throughout England, hearing cases, settling disputes and issuing charters and documents. She was a clever politician and gained a reputation for justice. She also had good financial sense, raising sums of money in her own name and funding a boat dock, called Queenhithe, on the River Thames to encourage overseas trade. From time to time, she crossed the English Channel to check on her and Henry's lands abroad.

Eleanor encouraged literature and introduced her native troubadour culture throughout their lands. She imported wines from Aquitaine, as well as spices, silks and exotic goods from the East, which she had discovered in her travels during the crusades. She improved the palace at Westminster, founded nunneries and gave money to religious institutions, including Fontevrault Abbey in Aquitaine.

A fair trial

Henry introduced trial by jury in England. Before then, a person had to go through combat or an ordeal to prove his or her innocence of a crime. Before Henry's reforms, if a woman was accused of a crime, such as witchcraft, she had to carry a red-hot iron for three steps. If her skin was burned, she was guilty.

1155–56

Eleanor is active in the government of England while Henry is abroad campaigning in Anjou and Maine.

1156

Henry and Eleanor travel to Aquitaine, where Henry puts down rebellious nobles.

Motherhood

A queen was expected to produce sons to continue the family line. Eleanor did this. In the first six years of her marriage to Henry, she had four sons and a daughter – William, Henry, Matilda, Richard and Geoffrey. Later she also had two more daughters, Eleanor and Joanna, and a final son, John. William died when he was three, but the others survived, which was unusual for a time when many children died from disease.

Above: Isabelle, queen of France, gives birth. Eleanor, like all medieval women, had her babies at home. Ladies-in-waiting were present and a midwife helped with the birth.

Eleanor gave birth in whichever castle she happened to be living in at the time. Poor women breastfed their own children, but noblewomen like Eleanor hired women, called wet nurses, to feed their babies. They were careful who they chose because they believed personality was passed through the milk.

After every birth Eleanor was up and about quickly, travelling on royal business. Often she took babies and nurses with her, but as her children grew, she left them in the care of the royal household. Eleanor bought toys and clothes for her children, but she had little to do with their everyday care.

1158

A royal pageant goes to France to arrange the betrothal of Louis' baby daughter to Eleanor's son, Henry.

1159

Probably encouraged by Eleanor, Henry marches on Toulouse in France but fails to take it.

Eleanor and Henry dreamed of extending their influence. This meant arranging successful marriages, or alliances, for their children. In 1158, Henry arranged for Prince Henry, then only three, to be betrothed to Louis VII's baby daughter, Margaret, from his second marriage. The two children were married in 1160. Henry gained the land of Vexin as a bridal gift, or dowry. However, his hopes of adding France to his empire ended in 1165 when Louis had a son who would inherit his throne. Despite this setback, two of Eleanor's daughters later became queens, and three of her sons became kings. Their descendants included many European kings and queens.

Eleanor's children

Eleanor had 10 children in all, two by Louis and eight by Henry. All her children, except Eleanor and John, died before she did.

By Louis VII:
Marie (1145–98)
Alix (1150–97)

By Henry II:
William (1153–56)
Henry (1155–83)
Matilda (1156–89)
Richard 'the Lionheart' (1157–99)
Geoffrey (1158–86)
Eleanor (1161–1214)
Joanna (1165–99)
John 'Lackland' (1166–1216)

Below: Medieval boys playing on hobby horses. Sons of the nobility learned to ride, hunt, fight and joust. They were often sent to other nobles for education. Thomas Becket became Prince Henry's tutor.

1162
Thomas Becket becomes Archbishop of Canterbury.

1165
Louis VII finally has a son, Philip. This ends Henry's hopes of gaining the French crown.

Courtly Love

Below: This image of a pair of lovers comes from *Romance of the Rose*, a French love poem written in the 14th century. In accordance with the rules of courtly love, the lover has to suffer and prove his worth before approaching his lady.

Knights in shining armour, beautiful ladies, tournaments and daring exploits are all elements of the medieval movement known as 'courtly love'. The key idea of the movement was pure love, particularly the adoration of a knight for the wife of his lord. Poems and music were written about lovesick knights and beautiful, untouchable ladies. However, it was an idealized picture, quite different from the reality of medieval marriage. But for women such as Eleanor, the ideas of courtly love must have had huge appeal: they showed women as superior, which was new and daring in the Middle Ages.

Courtly love began in Aquitaine in the 11th century. The ideas were made popular by troubadours, like Eleanor's grandfather and Bernard de Ventadour. Eleanor helped to spread courtly love through the courts of medieval Europe. Courtly love was linked to ideals of chivalry, a code of behaviour that knights were expected to observe. These ideals included being honourable, loyal and chaste (not pursuing physical relationships with women outside marriage). Of course, in reality, many knights failed to keep to these rules.

Left: A student declares his love to a noble lady. Courtly love poems and songs often told the stories of young unmarried men who offered their adoration to married noblewomen, knowing they could never be together.

'Sweet lady, for your love
With clasped hands, I bless
Your radiance, high above
My deep happiness.'

The 12th-century troubadour
Bernard de Ventadour

Below: Guinevere, wife of King Arthur, and the knight Sir Lancelot meet and kiss (far left). The legends of King Arthur became popular because they expressed the ideals of chivalry.

Separation

In 1166, Eleanor was 44. Her marriage to Henry, which had started so well, was in difficulty. Two years later they separated, and she set up court in Poitiers.

By the late 1160s, Henry's empire was in trouble. Nobles in Aquitaine, Maine, Anjou and Brittany were rebelling against his rule. Henry had unsuccessfully attacked the Welsh and was quarrelling bitterly with his old friend Thomas Becket, who was now Archbishop of Canterbury. Relations with Louis VII were also strained.

Eleanor was not happy in the marriage. Henry had fallen in love with a younger woman, Rosamond Clifford. He had had love affairs before, but Eleanor had ignored them. This time it was too public to ignore.

In addition, Henry was pushing Eleanor away from power and she was no longer a working queen.

Eleanor decided to return to Aquitaine. Diplomatically, she suggested to Henry that her presence in Aquitaine would help to calm rebellions. It suited everyone that Eleanor should return home, so Henry escorted her to Poitiers. Once there, he put down the rebellion brutally.

Gallant knight

In 1168 Eleanor was attacked by nobles in Aquitaine who wanted to punish Henry by taking her hostage. Her knights defended her and she escaped. One knight, William Marshal, was taken hostage. Eleanor paid his ransom. He became a close friend and a tutor for her sons.

1167

Eleanor prepares a lavish *trousseau* – furs, silks, and other fine goods – for her daughter Matilda's wedding.

1168

Eleanor goes to Aquitaine. In 1169, her sons Henry, Richard and Geoffrey pay homage to Louis VII.

Left: This stained-glass window in Canterbury Cathedral, England, shows Thomas Becket with Henry. Becket's murder shocked the Christian world. Henry was filled with guilt.

He made many noble families destitute, and a few went to seek refuge in France, where Louis offered asylum to Henry's enemies.

Henry left and Eleanor ruled Aquitaine on her own. Poitiers was her home base. Most of her family were with her – Prince Henry and his wife Margaret, her favourite son Richard, Eleanor, Joanna and Geoffrey with his future wife, Marguerite. Marie, Eleanor's first daughter from her marriage to Louis and now countess of Champagne, may have joined them. Eleanor had not seen Marie for 18 years. Eleanor's vassals were pleased she had returned. She worked hard to restore peace, ruling the duchy calmly and efficiently.

Eleanor turned Poitiers into a glittering cultural centre once again. Troubadours, musicians, poets, knights and noble ladies flocked to her court. There were feasts, festivals and tournaments – mock battles between mounted knights – which young Henry and Richard loved. Eleanor met up with her husband on various occasions but they never lived together again.

Thomas Becket

Henry made his chancellor Thomas Becket Archbishop of Canterbury. As chancellor, Becket's first loyalty was to Henry. As archbishop, his first loyalty was to God. The two close friends quarreled for many years. Finally, in 1170, four of Henry's officers murdered Becket. Henry became the most hated man in Europe, while Becket was canonized (made a saint) in 1173.

1170
Eleanor makes her son Richard her heir and has him made duke of Aquitaine in a spectacular ceremony.

29 December 1170
Thomas Becket is murdered in Canterbury Cathedral, England.

PRISONER AND STATESWOMAN

4

Rebellion and Betrayal

Between 1173 and 1174, Eleanor's eldest sons – Henry, Richard and Geoffrey – rebelled against their father with her support. The king crushed their rebellion and took Eleanor prisoner.

Previous page: When Eleanor was nearly 70 she crossed the Alps (shown here) on horseback into Italy. She crossed the Pyrenees when she was 78.

Below: This mural, which is in the chapel at Chinon, was discovered in 1964. It may show Eleanor (centre) being led away by King Henry (far right), or it may be Eleanor with Richard. No one is certain.

From the start of the 1170s, Eleanor devoted herself to her children's interests. Her eldest sons lived with her in Poitiers and had little respect for their father. They were teenagers – an age considered adult in medieval times – but had no power. Their father had decided their inheritance: Henry was duke of Normandy and Anjou and heir to the English throne; Richard was duke of Aquitaine; and Geoffrey was count of Brittany.

March 1173

Prince Henry escapes from Chinon and seeks support from Louis in France. Eleanor follows and is captured.

May 1173

Princes Henry and Richard invade Normandy, while Louis and Geoffrey attack the Vexin.

But their father continued to control the empire. Young Henry was not even allowed to rule England while his father was away.

Eleanor's sons grew resentful and Eleanor sided with them. In meetings with King Henry, she argued their case unsuccessfully. Behind his back, she started to plot against him. She approached her ex-husband, Louis, for his support, as well as her own vassals, who were keen to rebel against Henry's heavy-handed control.

Plots and spies

Some chroniclers (medieval historians) believed Eleanor planned the rebellion – others did not. But all agreed that she played a major role. Henry was shocked by her treachery. He may have placed spies in Poitiers, which is how he learned she was trying to escape and managed to capture her.

Hearing rumours, King Henry decided to keep his eye on the young Prince Henry and took him to Chinon. Young Henry escaped to France, where Louis agreed to join him in an attack on his father. Richard and Geoffrey followed. Henry knew Eleanor was involved and believed she and her court were turning his sons against him. She left Poitiers, disguised as a knight, to follow her sons, but was captured by Henry's men and put under guard.

In May 1173, war broke out. Eleanor's sons, with Louis and nobles throughout the Angevin lands, rose up against Henry. There were rebellions in England, and the Scottish king invaded – Henry was attacked on all sides. He gathered a huge force of mercenaries (paid soldiers) and counter-attacked. He moved speedily to put down the uprisings, attacked Poitiers, and broke up Eleanor's court. In July 1174, he took Eleanor to England and imprisoned her. He besieged Rouen and forced his sons and Louis to surrender. Henry made peace with his sons, but Eleanor stayed in prison.

September–November 1173
King Henry invades Poitiers. His forces suppress rebellions. A truce is called, then fighting begins again in spring 1174.

July 1174
Eleanor is imprisoned in Old Sarum Castle, Salisbury, England.

Prison and Loss

Eleanor was taken as prisoner to Old Sarum Castle at Salisbury, England. She was not locked up in a cell like a criminal – she could wander the castle freely. But she was cut off from family and friends, and was always under guard. It was a stark contrast to her previous life.

Henry did not know what to do about Eleanor. He suggested that they divorce and she go into a nunnery, as abbess of Fontevrault Abbey in Aquitaine, but Eleanor refused. She was not ready to disappear from the world completely.

Eleanor was still a queen, and from time to time she was allowed out, under guard. In 1176 she went to Winchester to help her youngest daughter, Joanna, prepare for marriage to the king of Sicily.

Below: When Eleanor was first captured she was taken to Henry's castle at Chinon. She was here for some months before being taken to England.

1175	1180
Eleanor rejects divorce and Henry's suggestion that she retire to Fontevrault Abbey.	Eleanor's first husband, Louis VII, dies. His son Philip succeeds him as king of France.

Left: A seal showing Henry II sitting on his throne. He was not prepared to share power with his sons – he was an absolute ruler and did not trust their ability to rule.

Henry's eldest sons continued to plot against their father. Henry now favoured his youngest son, John. He kept him close and angered the others by giving him lands belonging to them. In 1180, Eleanor's first husband, Louis, died. His son Philip became king of France and was determined to break the power of the Plantagenets.

Prince Henry died of dysentery in 1183. On his deathbed he pleaded for Eleanor's release. In November 1184, Henry summoned Eleanor to Westminster to discuss their sons' inheritance. She was now 62 and still beautiful, graceful and clever. Henry wanted Eleanor to persuade Richard to give Aquitaine to John, his favourite. There was a fierce row, and Eleanor refused. Two years later, Geoffrey died, trampled to death by a horse.

Henry was tired and seriously ill. His eldest surviving son, Richard, and King Philip of France had joined forces. They demanded Henry give up his lands and recognize Richard as king of England. Henry was upset when he learned that Prince John, his favourite, had also plotted against him. Shortly afterwards, Henry died. Eleanor was free once more.

Dream of death

When a messenger arrived to tell Eleanor of her son Henry's death, she said that she had foreseen his death in a dream. She dreamed he was lying on a couch, wearing two crowns. One was his solid gold crown, the other was of brilliant light. She knew her son had died and gone to heaven.

11 June 1183

Eleanor's eldest son, Prince Henry, dies. Three years later, her third son, Geoffrey, is killed.

6 July 1189

Henry II dies and is buried at Fontevrault Abbey.

Queen Regent

Eleanor was free and her beloved son, Richard, was king. She devoted herself to his interests, ruling wisely in his absence and preventing his brother John from seizing the throne.

Despite 15 years as a prisoner, Eleanor was as energetic and determined as ever. After his father's death, Richard stayed in Normandy settling his affairs. Eleanor paved the way for Richard's kingship, visiting great lords and receiving their oaths of allegiance on his behalf. She prepared a spectacular coronation for Richard, which took place in Westminster Abbey.

Less than a year after his coronation, Richard raised large sums of money and left on the Third Crusade with King Philip of France.

Knowing Richard had no heir, Eleanor arranged a marriage for Richard with a Spanish noblewoman called Berengaria of Navarre.

Left: Richard I (1157–99), named 'the Lionheart' for his bravery, was Eleanor's favourite son. He was brave and handsome, but could be very brutal.

3 September 1189
Richard is crowned king of England. He leaves on the Third Crusade the following year.

1190
Eleanor collects Berengaria, Richard's bride to be, and takes her to Sicily, reaching Richard before his departure.

Eleanor took Berengaria to Sicily to join Richard before he left for the Holy Land. Berengaria and Richard married but rarely lived together and had no children.

Eleanor settled in Normandy, ruling Richard's kingdom while he was away. She undid some of Henry's harsh laws and released prisoners. As she feared, John made two attempts to seize the throne. Philip of France, who returned early from the crusade, supported John. Each time, Eleanor moved swiftly. She roused support, prevented the invasions and kept the throne safe for Richard.

In 1193, Eleanor heard that Richard had been captured on his way back from the crusade by the German emperor, Henry VI. Eleanor raised Richard's ransom and took it to Germany. Back in England, Richard was greeted as a conquering hero. He had won the cities of Jaffa and Acre from the Muslims, but had failed to capture Jerusalem.

In 1194, Eleanor and Richard went to live in their Angevin lands across the English Channel. Eleanor never returned to England. She persuaded John and Richard to make peace, and then retired to the Fontevrault Abbey. Philip continued to wage war against Richard. In 1199, Richard was wounded in France. Knowing that he was dying, Richard made John his heir. Eleanor rushed from Fontevrault and was with her son when he died.

An incredible journey

Eleanor was almost 70 when she crossed the Pyrenees to Navarre to collect Berengaria. She travelled back over the Pyrenees on horseback with the young princess and a small escort, then through the Alps into Italy, down the western coast, and by boat to Sicily, where they met up with Richard. After only four days' rest, she made the return journey. Her round trip was an extraordinary 2,500 miles (4,000 km).

1193–94
Eleanor raises Richard's ransom of 150,000 silver marks, equal to 35 tonnes of silver.

1199
Richard dies of a battle wound. John succeeds him as king of England.

Women and the Church

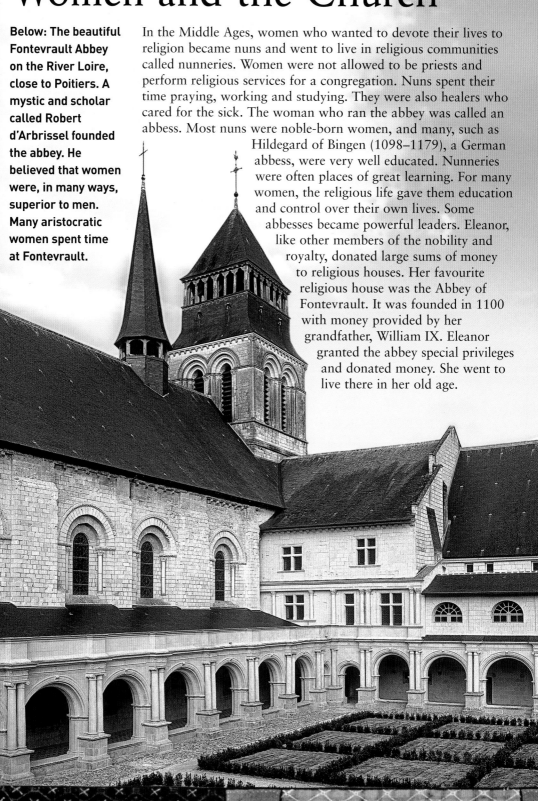

Below: The beautiful Fontevrault Abbey on the River Loire, close to Poitiers. A mystic and scholar called Robert d'Arbrissel founded the abbey. He believed that women were, in many ways, superior to men. Many aristocratic women spent time at Fontevrault.

In the Middle Ages, women who wanted to devote their lives to religion became nuns and went to live in religious communities called nunneries. Women were not allowed to be priests and perform religious services for a congregation. Nuns spent their time praying, working and studying. They were also healers who cared for the sick. The woman who ran the abbey was called an abbess. Most nuns were noble-born women, and many, such as Hildegard of Bingen (1098–1179), a German abbess, were very well educated. Nunneries were often places of great learning. For many women, the religious life gave them education and control over their own lives. Some abbesses became powerful leaders. Eleanor, like other members of the nobility and royalty, donated large sums of money to religious houses. Her favourite religious house was the Abbey of Fontevrault. It was founded in 1100 with money provided by her grandfather, William IX. Eleanor granted the abbey special privileges and donated money. She went to live there in her old age.

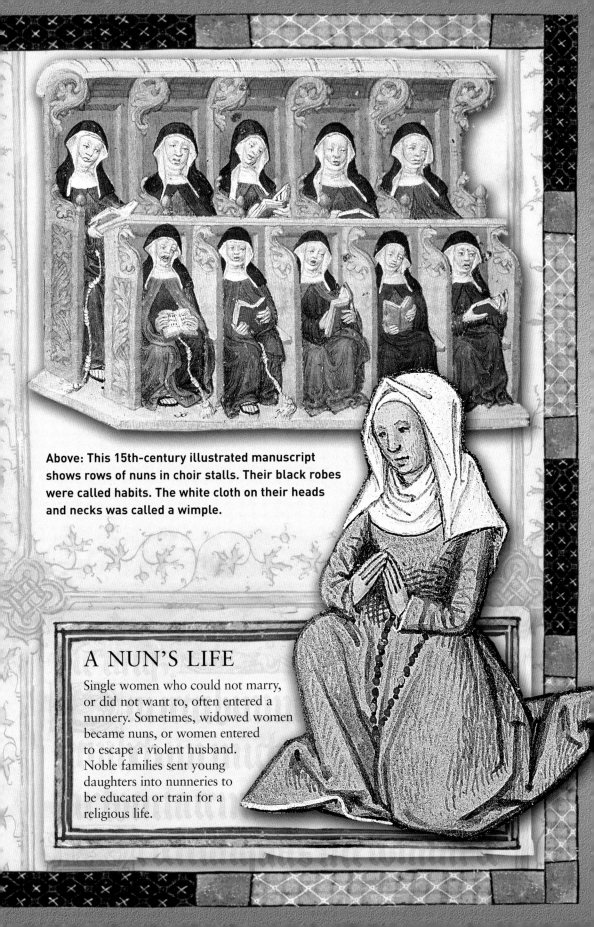

Above: This 15th-century illustrated manuscript shows rows of nuns in choir stalls. Their black robes were called habits. The white cloth on their heads and necks was called a wimple.

A NUN'S LIFE

Single women who could not marry, or did not want to, often entered a nunnery. Sometimes, widowed women became nuns, or women entered to escape a violent husband. Noble families sent young daughters into nunneries to be educated or train for a religious life.

Death and Legacy

With Richard dead, Eleanor worked to support John. He was her least favourite son, but Richard had named him heir to the English throne as well as to Aquitaine, Normandy and Anjou. But there was another claimant to the throne: her grandson, Arthur, who was Geoffrey's son. Arthur was in league with King Philip of France.

Eleanor was now 77. She set off on a grand tour of Aquitaine to prepare the way for John. In her wish for peace, and to ensure loyalty to John, she even did homage to Philip, king of France. In three months, she covered more than 1,000 miles (1,600 km). In a further effort to ensure peace, Eleanor arranged for her granddaughter, Blanche, to marry Prince Louis, the grandson of her former husband, Louis.

In 1202, however, war broke out. John had angered Philip who, together with Arthur, launched an attack. Arthur marched on Aquitaine and besieged Eleanor in Mirabeau castle. Eleanor managed to hold out until John arrived to rescue her. Exhausted, Eleanor returned to Fontevrault Abbey, where she died on 1 April 1204. Soon after her death, Normandy and Anjou fell to the French, but Aquitaine stayed under Plantagenet control for another 200 years.

> 'She enhanced the grandeur of her birth by the honesty of her life... she surpassed [bettered] almost all the queens of the world.'
> **Nuns of Fontevrault on the death of Eleanor of Aquitaine**

25 May 1199
Eleanor's son, John, is crowned at Westminster Abbey, London.

1200
Eleanor travels to Castile to collect her granddaughter Blanche.

Final journey

In 1200, Eleanor made a final, remarkable journey, travelling over the Pyrenees into Spain. It was January and there were storms and sleet. She arrived in Castile, where she met up with her daughter and namesake, Eleanor, for the first time in 30 years. Eleanor chose her granddaughter, Blanche, to marry Louis, prince of France. It was a wise choice. Blanche became a great queen.

Eleanor was an extraordinary woman. She was a headstrong girl who became a wise stateswoman. Married to two kings, she played a major role in political events, which was unusual for women of that time. Through diplomacy and clever alliances she helped to create an empire. She was criticized for troublemaking, but she was brave and independent. She remains one of history's most impressive queens.

Below: The tomb effigies of Eleanor and Henry II of England in Fontevrault Abbey. Eleanor was 82 when she died – a remarkable age for the time.

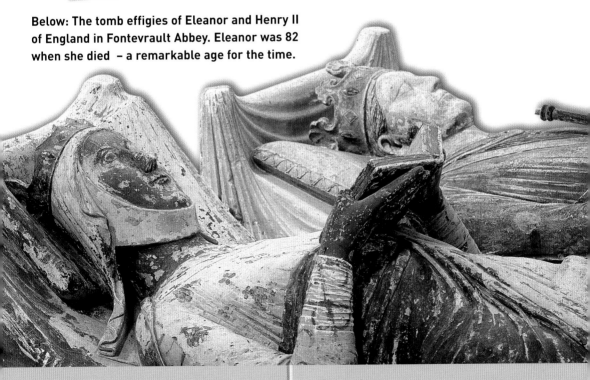

1202

Eleanor's grandson Arthur besieges her in Mirabeau. John rescues her and imprisons, or possibly kills, Arthur.

1 April 1204

Eleanor dies and is buried at Fontevrault Abbey, together with Henry II and her son Richard.

Glossary

abbess the highest-ranking woman in an abbey.

allegiance loyalty toward a ruler.

Amazons in ancient Greek myths, the Amazons were a race of fierce women warriors.

Angevin Empire the name given to Henry II's empire which was centred on the town of Anjou.

baron a nobleman of any rank.

besiege to surround a castle or town in order to force the inhabitants to surrender.

betrothed to be engaged to be married.

broom a small shrub with yellow flowers.

Byzantine Empire the eastern part of the Roman Empire, created when the Roman Empire collapsed. It lasted from A.D. 330 to 1453.

charter document issued by a king or queen granting rights to a person or organization.

chivalry the rules of behaviour followed by knights and nobles in medieval Europe.

cleric a religious official.

conjurer an entertainer who performs magic tricks.

count a nobleman who ranks below a duke.

county in medieval times, an area ruled by a count.

courtly love a medieval movement that idealized a knight's pure love for a noblewoman, who was usually married.

crusades military expeditions made by European Christians in the Middle Ages to take the Holy Land from Muslims.

destitute without money, food or shelter.

domain an area of land controlled by a ruler or royal family.

dowry the money and property that a woman or her parents give her husband on the marriage.

duchy in medieval times, an area ruled by a duke. It could be independent of a king if the duke was very powerful.

duke a nobleman of the highest rank below that of a prince.

effigy a carved figure of someone, which is usually found on a tomb.

excommunicate to expel or throw someone out of the Roman Catholic Church.

fealty an oath of loyalty to a superior, such as a lord, duke or king.

feudalism a term used to describe the system of landholding in medieval Europe. Tenants held land granted by kings or lords in exchange for military service.

fief the land given by the king to nobles in exchange for military service.

heir a person who can legally inherit property or a title from someone when that person dies.

Holy Land part of the ancient Middle East. Today, the area includes Jordan and Israel.

homage a show of loyalty. A medieval knight did homage to his lord by placing his hands in the palms of his lord. In exchange, the knight received a kiss of peace.

jongleur a word of French origin which means juggler, or entertainer.

keep the central tower inside the walls of a medieval fortress or castle.

litter a couch suspended on poles and carried on people's shoulders or by horses.

marionette a type of puppet that is controlled by strings.

medieval relating to the Middle Ages.

Middle Ages a time in European history between the fifth century and the mid-1400s.

moat water that surrounds a castle.

noble someone belonging to the aristocratic class, with social privileges and power.

overlord a ruler, such as a king, who holds power over lesser rulers, such as counts.

penance a punishment willingly undergone after committing a sin.

petition a formal request.

pilgrimage a religious journey made to a sacred place, such as a shrine.

privilege a right or benefit granted by a ruler to a person or organization.

Provençal a language that was spoken in southern France in the Middle Ages.

ramparts the fortified walls that surround a castle or fortress.

regent a person who governs a territory when the king or queen is away or unable to do so, for a reason such as illness.

retinue people who follow and serve an important person, such as a king or duke.

rushes grass-like plants whose leaves can be dried and were once used to cover a floor instead of a carpet.

scribe a person who copies manuscripts or writes out documents.

sprig a small shoot or piece of a plant.

stateswoman a respected leader who is devoted to public service; also statesman.

tabor a small medieval drum.

tournament a competition between knights fighting on horseback with lances and shields or on foot with swords, maces and shields.

troubadour poet who wrote and sang verses about love.

trousseau clothing and personal possessions collected for a bride.

vassal in the feudal system, a powerful lord who received land from the king in return for an oath of loyalty and a promise to provide military service.

witness declare a document to be correct and valid by signing it.

Bibliography

Weir, Alison, *Eleanor of Aquitaine: By the Wrath of God, Queen of England*, Pimlico, London, 2000

Eyewitness Guide: Medieval Life, Dorling Kindersley, London, 1996

History in Writing: The Crusades, Evens Brothers, London, 1999

Schoyer Brooks, Polly, *Queen Eleanor: Independent Spirit of the Medieval World,* Houghton Mifflin, Boston, 1983

Eastwood, Kay, *Women and Girls in the Middle Ages,* Crabtree, Ontario, 2004

Sources of quotes:

p.33 *Eleanor of Aquitaine: By the Wrath of God, Queen of England,* Alison Weir, p.19

p.41 *Eleanor of Aquitaine: By the Wrath of God, Queen of England,* Alison Weir, p.132

p.45 *Queen Eleanor: Independent Spirit of the Medieval World,* Polly Schoyer Brooks, p.67

p.58 *Queen Eleanor: Independent Spirit of the Medieval World,* Polly Schoyer Brooks, p.164

Some web sites that will help you to explore Eleanor of Aquitaine's world:

www.royalty.nu/Europe/England/Angevin/ Eleanor.html

www.womeninworldhistory.com/heroine2.html

en.wikipedia.org/wiki/Eleanor_of_Aquitaine

library.thinkquest.org/12834/text/ sistercities.html

www.yourchildlearns.com/castle_history.htm

mw.mcmaster.ca/timeline.html

Index

Acknowledgments

AA = The Art Archive, BAL = The Bridgeman Art Library, SHP = © Sonia Halliday Photographs.

B = bottom, C = centre, T = top, L = left, R = right.

Front cover Statue of Eleanor at Chartres Cathedral/SHP; 1 AA/Bibliothèque Municipale, Dijon/Dagli Orti; 3 John Parker; 4T BAL/Musée Condé, Chantilly; 4B akg-images; 5T, 5B John Parker; 7, 8 BAL/Musée Condé, Chantilly; 9 Corbis/© Ric Ergenbright; 11 John Parker; 12, 13T SHP; 13CR SHP/Bibliothèque Nationale, Paris; 13L BAL/Bibliothèque Nationale, Paris; 14 AA/British Library, London; 15 BAL/ Bibliothèque Municipale, Dijon; 16 AA/Bibliothèque Universitaire de Mèdecine, Montpellier/Dagli Orti; 17 AA/Victoria and Albert Museum, London/Graham Brandon; 19 akg-images; 20 BAL/Bibliothèque Nationale, Paris; 21 BAL/Musée Condé, Chantilly; 22 AA/Bibliothèque Municipale, Castres/Dagli Orti; 23 Scala, Florence/British Library, London; 24 John Parker; 25 BAL/Louvre, Paris; 26 SHP; 27 John Parker; 28 BAL/Bibliothèque Nationale, Paris; 29T SHP/Bibliothèque Nationale, Paris; 29B Scala, Florence; 30 BAL/Bibliothèque Nationale, Paris; 31 AA/Basilica San Marco, Venice/Dagli Orti; 32 BAL/Bibliothèque Nationale, Paris; 35 John Parker; 36 akg-images/British Library, London; 37 AA/Musée de Tessé, Le Mans/Dagli Orti; 38 John Parker; 39 Getty Images/Stone; 40 BAL/British Library, London; 42 BAL/Bibliothèque Municipale, Boulogne-sur-Mer; 43 AA/Bodleian Library, Oxford; 44, 44–45 AA/ British Library, London; 45T AA/Bibliothèque Universitaire de Mèdecine, Montpellier/Dagli Orti; 45B Scala, Florence/British Library, London; 47 SHP; 49, 50, 52 John Parker; 53 AA/British Library, London; 54 Scala Florence/British Library, London; 56 John Parker; 57T Scala, Florence/British Library, London; 57BR AA/Bodleian Library, Oxford; 59 John Parker.

Contents

Look for the Then and Now boxes. They highlight parts of Viking culture that are present in our modern world.

Any words appearing in the text in bold, **like this**, are explained in the glossary.

What did the Vikings do for me?

The Vikings sailed in big, wooden ships across the North Sea and northern Atlantic Ocean, in search of gold, silver, and other treasures. Wherever they landed, they attacked towns and villages. Sometimes they burned houses, churches, and **monasteries**. Vikings were fierce warriors who were feared everywhere they went.

However, violent attacks and raids were not all there was to Viking society. The men spent most of their time working as farmers. They also fished, hunted, and built boats. The women cared for their children and households. When the men went to sea, the women ran the farms. Both men and women wore jewellery and wove cloth with beautiful designs.

Look at the Viking scene below. It seems very different to modern times, but you might be surprised to discover some things the Vikings did that we still do today.

Who were the Vikings?

About 14,000 years ago, settlers travelled west to what is now Norway and Sweden. Over time, they moved further west and south to Denmark. Today, we call these countries Scandinavia and the people Scandinavians.

This map shows the main Viking settlements and trade routes during the **Viking Age** (AD 800–1100).

GREENLAND

ICELAND

Shetland Islands

SWEDEN

NORWAY
Oslo •

RUSSIA

NORTH AMERICA

Scotland
Lindisfarne
IRELAND
Dublin •
England
London •
DENMARK

Kiev •

Newfoundland

ATLANTIC OCEAN

• Paris

FRANCE

Istanbul
(Constantinople)

SPAIN

Mediterranean Sea

MIDDLE EAST

NORTH AFRICA

■ Viking settlements
← Viking trade routes
• Cities
— Modern-day borders

0 500 1,000 Miles
0 500 1,000 Kilometres

Ancient Scandinavians

The early Scandinavians didn't settle in one place. Instead, they followed reindeer and other herds so that they could hunt them. This changed in about 4000 BC, when they began to settle down and farm the land. They had a short growing season during which they grew grains and vegetables. Cattle, sheep, goats, and pigs gave them meat and milk during the long, cold winters. They began to make metal tools, pottery, cloth, and jewellery.

All over Scandinavia, people had similar customs and beliefs. However, they began to think of themselves as different people. Some were Danes, some Norwegians, and some were Swedes. By about AD 500, these groups traded with other Europeans.

Religion

Christianity came to Europe by AD 100 or 200, but the Vikings kept their **pagan** beliefs for a long time. They worshipped many gods, including Odin, the god of war, and Thor, the god of thunder. Pleasing the gods was important to the Vikings. Warriors believed that if they died bravely in battle, they would live forever with Odin, in his palace, Valhalla.

This painting from 1872 shows the Viking god Thor fighting giants.

Wednesday, Thursday, Friday

Three days of the week are named after Viking gods. Wednesday comes from Odin, the god of war, who was also sometimes called Woden. Thursday is named after Thor, the god of thunder. Freya, the goddess of love, gave her name to Friday.

What was Viking society like?

Most Vikings were farmers. A farmer's household was made up of grandparents, parents, children, aunts, uncles, cousins, servants, and slaves.

Farms

Whole farming families lived together in a longhouse. This was a house made up of one large room, about 12–15 metres (40–50 feet) long. Sometimes one bedroom was screened off, but usually all family members slept together in one room. There was a fireplace in the middle, for warmth and cooking. Many farmers also had barns. Some farmers even had a dairy and a blacksmith's **forge**.

This modern reconstruction shows what a Viking longhouse would have looked like.

THEN...

The Vikings invented ice skates. They used horse or cow bones strapped to their feet with leather. They pushed themselves across the ice with a long stick. Bone skates were slow. Skaters could only go about 4 kilometres (2.5 miles) an hour.

Transport

Farms were often by the coast, or near rivers and lakes. During the warm months, the Vikings used boats to travel from farm to farm. When the water froze over in winter, they needed skates, skis, and sledges instead. The sledges were pulled by horses. The Vikings would fasten iron **cleats**, called frost-nails, to the horses' hooves. This meant that the horses would not slip and slide all over the ice!

Skis

Early paintings show that Viking hunters used skis to go hunting in winter. The skis were not so different from today. They were made from two curved planks with leather straps to slide the feet into.

This illustration from the 1500s shows Viking hunters using skis.

...NOW

Skates have changed a lot! Between **AD** 1200 and 1400, iron began to be used instead of bone. By the 1700s, steel blades were fitted to leather boots. Today, blades are so thin and light that a good skater can go as fast as 24 kilometres (15 miles) an hour.

Kingdoms

By the beginning of the **Viking Age** (about AD 800 to 1100), dozens of small kingdoms or chiefdoms existed throughout Scandinavia. A king would promise to protect the people from attack. In return, the people promised to be loyal to the king.

Vikings in Iceland held a yearly meeting, or *thing*, at Thingvellir, near the coast.

THEN...

Viking criminal trials took place at the *thing*. A group of 12 men, called a **jury**, would decide whether the accused was guilty or innocent. Occasionally the guilty were outlawed and could be killed, but usually they would only have to repay their victim.

Things

Each kingdom held a meeting once or twice a year called a *thing*. Nearly all men, except slaves, went to the meeting and many spoke there. If they were not pleased with their king, they chose a new one. They also made laws and settled arguments. Years later, the Vikings took the idea of the *thing* with them when they settled down in new lands.

Modern juries include both men and women. They include people from different backgrounds.

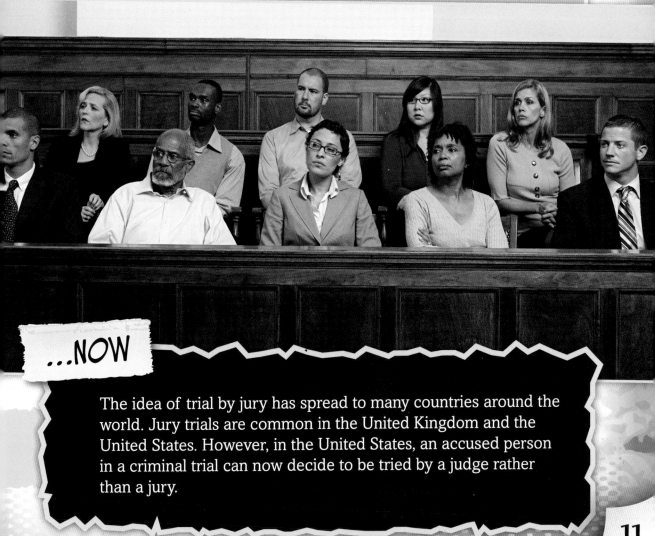

...NOW

The idea of trial by jury has spread to many countries around the world. Jury trials are common in the United Kingdom and the United States. However, in the United States, an accused person in a criminal trial can now decide to be tried by a judge rather than a jury.

How did the Vikings build ships?

In the AD 700s, Scandinavia had few cities or towns. Most people lived along the coasts on large farms. They used boats for fishing and trading with one another. People from Europe visited the coastal farms, looking for furs, timber, and other goods. Sea-trade with Europe grew.

Viking warships were called longships. They were fast and sturdy, and could hold 60 men. The longships were carried along on the wind by sails. On days when there was little wind, the men rowed the boats through the water. Both ends of a longship were the same shape. This meant that a ship could change direction on a narrow river without having to turn around.

Viking sails were made from wool, which has a natural oil in it called lanolin. This oil made the sails waterproof.

THEN...

Viking shipbuilders used iron **rivets** (metal pins) to fasten overlapping planks, or boards, together. These **clinker-built** ships were fast, and they worked equally well in shallow or deep waters. Most boats need time to swell when they are first put in the water, or they will leak. Not the clinker-built boats. They can be sailed as soon as they hit the water.

Ships used for trading were called knarrs. They were shorter and broader than a longship, and had plenty of space to carry goods to trade. The Vikings also used knarrs to move all their belongings and animals when they settled in a new country.

Notice how the boards overlap on this modern clinker-built fishing boat.

...NOW

Wooden boat builders throughout the world continue to make clinker-built boats. Overlapping wooden boards make for fast and sturdy fishing boats, rowboats, and yachts. These boats use oars, sails, and even motors to glide through the water. Several boat-building schools throughout the world teach students to build boats like the Vikings did.

Who were the Viking raiders?

In AD 793, some Vikings attacked a **monastery** at Lindisfarne, an island off the north-east coast of England. They arrived in small boats, rushed ashore, and stole gold, silver, and other valuable items. They were so fierce, strong, and unbeatable that they spread fear all over Britain. This raid marks the beginning of the **Viking Age**.

Viking raiders were armed with swords, spears, and axes. They carried shields for protection. Wealthy leaders also wore iron helmets and chain mail tunics.

THEN...

While they were away, farmers depended on their wives to run the farms. They held a ceremony handing the keys to their wives. If a Viking died at sea, his wife became owner of the farm and could sell it or keep it running. If a Viking woman divorced her husband, she kept part of the household wealth. Viking law gave women property rights.

Some of these frightening fighters were full-time warriors, but many were just farmers. They left on raids in the spring, after all their crops were planted. They came home in midsummer for the harvest. Then they would set off on another raid in the autumn.

While the Viking men left on raids, the women looked after the houses and farms.

...NOW

The Vikings were ahead of the rest of the world in recognizing women's rights and abilities. Unfortunately, many of those rights were lost over time. It was not until the 1800s that laws were passed in the United Kindom, the United States, and much of Europe that gave women the right to own and control property. Today, women in most countries around the world can own their own property. However, there are still many places where women are not treated equally to men.

Moving in

Viking kings grew rich from their raids. They were able to train and equip large armies. In AD 841, one of these armies landed in Ireland. They conquered Ulster and founded a settlement that would become Dublin. Instead of raiding and then returning home as they had once done, the Vikings settled in Ireland. However, this didn't mean they stopped raiding! Using Ireland as a base, the Vikings attacked towns, **monasteries**, and farms in Scotland and England.

In AD 865, a Viking army from Denmark invaded England. The next year, this army captured the city of York and settled there. They called it Jorvik. They built houses with thatched roofs, farmed, and set up businesses. As the population grew, they added new streets and buildings.

Craftsmen made combs, knives, jewellery, shoe buckles, leather goods, and pottery. Traders took these goods all over Europe. When they came home, the traders brought clothing, spices, and perfumes. Jorvik became a famous trading centre.

Combs

Viking combs could be made from wood or bones, or deer, reindeer, and elk antlers. They could be single- or double-sided. The wealthy owned combs with delicate carvings on them, while the poor had very simple ones.

THEN...

Both English and the Viking language, called Old Norse, are Germanic languages. This means that the English and the Vikings were probably able to understand each other. Over time, the languages began to blend even more, and many Old Norse words became part of English.

These Viking combs and hair picks were found in Ireland.

We still use many Viking words today. For example, *egg*, *root*, and *kid* came from Old Norse. Also, *sister* and *husband*, as well as *anger*, *cake*, *fellow*, *get*, *rug*, *scrub*, *skin*, *take*, and *ugly*. There are many others, including a lot of words to do with the law, farming, and trade.

Normans

At the same time as some Viking armies were attacking Britain, others were invading France. In AD 885, an army of 30,000 Vikings marched on Paris. They held it for two months, but were defeated. Instead, they settled down to farm in Normandy, in northern France. They became known as Normans, and began to speak French and to take on French customs.

During the Viking battle at Suffolk in AD 869, Vikings attacked and murdered the British King Edmund.

Berserkers

Berserkers were fierce Viking warriors who howled and bit their shields before battle. They believed that their anger gave them strength.

THEN...

Fear of Viking raids forced people throughout Europe to unite into nations. According to experts, this was a major change in the history of Europe. Small kingdoms had a difficult time defending themselves, but when they joined together they became stronger. In England, the rule of William the Conqueror halted further Viking attacks.

The Danelaw

By AD 885, all of north-east England was under Viking control. This area became known as the Danelaw, and stretched from north of York all the way to London in the south. The Danelaw followed Viking laws and customs.

Later on, a new wave of Vikings attacked and conquered England. The leaders of these new groups became kings of England. However, in 1066, the Norman duke William the Conqueror invaded Britain from across the English Channel. William became the new ruler of England.

On this map, the purple line divides England. All of the land to the north-east was called the Danelaw, and was under Viking rule.

...NOW

Although history doesn't tell us if this was a direct result of the Vikings, this pattern of large, powerful nations continues today. The countries in Britain joined to become the United Kingdom. Even in America, the colonies found strength in joining together to form one nation, the United States. Larger nations are better able to defend themselves and to grow strong.

What new worlds did the Vikings explore?

The Vikings were forced to look for new lands to settle because they were running out of good farmland at home. They were helped in this by changes in the climate. The weather became warmer than it had been in earlier centuries. This meant that the Vikings could explore new lands for a longer part of the year.

Iceland

By AD 870, the Vikings had moved further west to Iceland. Even though farming was difficult in the cold, windy island, the settlements there grew rapidly. By AD 930, there were 30,000 people. A hundred years later, this figure had doubled to 60,000.

In Iceland, the Vikings established a *thing* to make and enforce laws. It became known as the *Althing*, and it still survives today as Iceland's national parliament.

Furs for nuts

Greenland's Viking settlers traded polar bear skins, walrus ivory, and furs for timber, tools, and special treats like raisins and nuts.

THEN...

Some experts call the Vikings the first oceanographers. Viking settlers used ocean currents to decide where to build towns and farms. In AD 874, Ingólfur Arnarson threw wooden pillars overboard as he approached Iceland. He made his home where the wood landed (present-day Reykjavik, Iceland's capital). He knew that the ocean currents that guided the wood to land would also help ships find their way.

Greenland

In AD 982, the Viking Eric the Red set sail westwards from Iceland. He saw a new land covered with ice. He called his discovery Greenland. It was colder than Iceland and it wasn't green, but he hoped that naming it Greenland would encourage others to join his settlement. The first settlers built dairy and sheep farms. Under Eric's leadership, Greenland's population reached 3,000.

This modern painting shows Eric the Red setting sail for Greenland with the crew of his Viking longship.

...NOW

Today, ships still use ocean currents to cut fuel costs. For example, a major shipping company in Japan tracks ocean currents. Then it guides its fleet of large oil carriers into the currents to save fuel.

America

When Leif Eriksson, son of Erik the Red, heard rumours of an unexplored land to the west, he set off to find it. He reached Labrador, in Canada sometime between AD 997 and 1003. He called it *Markland*, or Forest Land, and settled there for the winter.

Viking sagas tell of four other journeys to America between AD 1000 and 1030. Vikings settled at L'Anse aux Meadows in Newfoundland, Canada. They used it as a base while exploring the North Atlantic coast. The land was excellent for farming and timber, but the small band of Vikings could not defend themselves against the large numbers of Native Americans who already lived there. They returned to Iceland.

The Vikings called the Native Americans *skraelings*, which may have meant "screamers" or "screaming weaklings". However, the Native Americans were actually strong and frightening. One of the first meetings between the Vikings and *skraelings* ended in a deadly battle. The Vikings killed eight Native Americans. The *skraelings* fought back and killed the Viking leader.

The first Norwegian-American

Snorri Thorfinnsson, who was born between AD 1004 and 1013 in L'Anse aux Meadows, is thought to be the first European born in North America. When he was a child, his family returned to Iceland. Snorri Thorfinnsson became an important Icelandic leader.

THEN...

Wherever the Vikings went, they settled down. Warriors would marry local women and have families. Their children often looked like them, so Viking features were passed on to their **descendants**.

Several Viking accounts tell of battles between Viking warriors and Native Americans.

Many people in the United Kingdom are descended from Vikings. It is thought that up to 50 per cent of people in some parts of north-east England might have a Viking **ancestor**. There area probably the same number of Viking descendants in Ireland and Scotland, too.

Russia and the East

While Vikings from Denmark and Norway headed west and south, the Swedes travelled east. Most Swedish Vikings were settlers and traders, not pirates. In AD 858, they captured present-day Kiev and Novgorod. From here, they spread into neighbouring villages. These Swedish settlers were called the Rus.

At first the Rus were outsiders, but soon they began marrying people from the area, speaking their language, and even taking their names.

Traders

Some Swedish Vikings set up farms in Russia. Others began trading. Viking traders travelled 800 kilometres (500 miles) along the River Dnieper to the Black Sea. They crossed

Russia

The country Russia gets its name from the Rus, the Vikings who invaded it so long ago.

the sea to Constantinople, which is now known as Istanbul and is the capital of Turkey. The markets in Constantinople had riches from all over Asia, such as spices, silks, and jewellery. The Vikings took their own goods there to sell.

THEN...

Viking trade routes stretched from Greenland in the west to Turkey in the east. Traders carried goods and information all along their routes. They showed people things they had never dreamed of before. For example, a small, bronze Buddha statue from India has been found in far away Sweden!

Here, Viking goods are being loaded on to a trading ship, known as a knarr. They will be transported to distant lands for trading.

...NOW

Today we depend on worldwide trade. Goods made in China are sold all over the world. Japanese cars can be bought in Europe. African coffee is used everywhere. Trade is greater and faster today than it was in the **Viking Age**, but we like foreign goods just as much as the Vikings did! Even though the Vikings probably did not invent the concept of global trade, they no doubt had a huge influence on it throughout history.

Where are the Vikings today?

The Vikings are not forgotten today. We use Old Norse words every day and live in cities first built by the Vikings. We may know people who are the **descendants** of Vikings, or be descended from them ourselves.

Celebrating the Vikings

Viking stories still capture our imaginations. Children and adults enjoy dressing up as Vikings. **Re-enactment** societies all over the world hold pretend battles. People wear Viking clothing and carry axes and swords. No one gets hurt. It's just for fun!

This photograph shows the celebration of Up Helly Aa, a Scottish fire festival. People burn Viking-style ships, dress as Vikings, and sing songs in Old Norse.

This Swedish football fan has dressed up to support his team during the 2006 World Cup in Germany. "Vikings" is a popular team name in many sports.

Horned helmets

Many people think that the Vikings wore helmets with big horns on them. Actually, they didn't! Warriors wore a sheepskin cap with an iron helmet over it. A metal piece came down in front to cover the warrior's nose.

Key dates

Here is an outline of important moments in the history and culture of the Vikings:

14,000 years ago	Settlers move into Scandinavia from the east
4,000 years ago	Ancient Scandinavians begin farming
AD 500	Scandinavians are trading with other Europeans
700	The Vikings excel at shipbuilding
793	A raid on Lindisfarne marks the beginning of the **Viking Age**
832	Ireland is raided three times in one month
841	Vikings conquer Ulster and found a settlement that will become Dublin
858	Swedish Vikings take over Novgorod and Kiev

866	A Viking army captures York and some Vikings begin settling down in the lands they have invaded
870–930	Vikings settle in Iceland
885–86	Vikings attack Paris
900	Vikings settle in north-west England
907	Vikings reach Constantinople and begin trading with the city
911	Vikings settle in Normandy
940–954	The Vikings and the English fight over York
986	Eric the Red leads the settlement of Greenland
Late 900s	Voyages to North America begin
990–1030	Vikings settle in present-day Canada
1066	The Battle of Hastings marks the end of the Viking era

Glossary

AD short for Anno Domini, which is Latin for "in the year of our Lord". AD is used for all the years after year 1.

ancestors all the past members of a family. Many people today have Viking ancestors.

BC short for before Christ. BC is used for all the years before year 1.

cleat metal strips designed to protect against slipping. Boots with cleats help us walk on ice.

clinker-built ship built with overlapping boards. Viking boats were clinker-built.

descendant someone's descendants are the people who live at a future date in the same family. The Vikings left descendants wherever they settled.

forge blacksmith's workshop. Viking farms often had a forge.

jury group of people chosen to make a decision. Viking juries judged criminals and solved problems.

monastery place where monks live and worship. Vikings raided monasteries looking for gold.

pagan person who believes in more than one god. Vikings were pagans.

re-enactment perform something again. Re-enactment societies perform Viking battles in modern times.

rivet metal pin used to hold pieces together. Viking boat builders used rivets to hold the wood together.

thing assembly held once or twice a year in Viking settlements. Viking laws were made at *things*.

Viking Age period between AD 800 to 1100, when the Vikings raided, explored, and traded all over the world. The Viking Age was a time of great change.

Find out more

Books

History From Objects: The Vikings, John Malam (Wayland, 2010)

The Gruesome Truth About: The Vikings, Matt Buckingham (Wayland, 2010)

Tracking Down: The Vikings in Britain, Moira Butterfield (Franklin Watts, 2010)

Websites

www.bbc.co.uk/schools/primaryhistory/vikings/
This website has lots of information about Viking culture in Britain.

www.mnh.si.edu/vikings/start.html
Find out more about the Viking exploration of Greenland and North America on this useful website.

www.pbs.org/wgbh/nova/vikings/
This web page has lots of information on Viking history. You can explore a Viking village and learn how to write your name in the Viking alphabet.

A place to visit

JORVIK Viking Centre
Coppergate
York YO1 9WT
www.jorvik-viking-centre.co.uk

Index